To Victoria

SECRET
GUILDFORD

With very best wishes

Marion Field

Marion Field

AMBERLEY

Acknowledgements

Russell Scobbie
Mary Alexander
Rachel Humphries
John Bassett

First published 2018

Amberley Publishing
The Hill, Stroud
Gloucestershire, GL5 4EP

www.amberley-books.com

Copyright © Marion Field, 2018

The right of Marion Field to be identified as the
Author of this work has been asserted in accordance
with the Copyrights, Designs and Patents Act 1988.

ISBN 978 1 4456 7394 3 (print)
ISBN 978 1 4456 7395 0 (ebook)

British Library Cataloguing in Publication Data.
A catalogue record for this book is available from the
British Library.

Origination by Amberley Publishing.
Printed in Great Britain.

Contents

1. A History of Guildford

Guildford has a long and fascinating history. It sits in a gap in the chalk hills created when the River Wey flowed through the North Downs towards the River Thames. The origin of the town's name is not clear, but the 'Guild' may be a reference to the 'golden sands' on the riverbed and the riverbank. The development of a ford on the west bank of the river accounts for the second syllable.

It is likely that a Saxon village consisting of rectangular wooden huts was built here. The Saxons migrated from north-west Europe in the sixth century AD. They were pagans and may have worshipped on St Catherine's Hill where a ruined fourteenth-century chapel still stands. Tradition suggests that the Saxon King Ethelred built a palace on the site of the later Norman castle.

The Saxon settlement was later moved to the eastern bank of the river and a watchtower was built. When the 'Mount', on the west side of the Downs, was excavated in 1929, thirty-five skeletons were found buried with all the accoutrements they would require in the afterlife. The following century, when the pagan Saxons had been converted to Christianity, a small wooden church was erected on the side of St Mary's Church in Quarry Street.

In 880 Alfred the Great left to his nephew Aethelward his 'royal residence at Gyldeforda'. This is the first time the town's name appears in a written document. During the tenth century, Guildford developed as an important commercial centre and a Royal Mint was set up in the town giving it the status of a borough.

The start of the eleventh century saw an invasion by the Vikings from Norway under Canute. He defeated the Saxon King Ethelred, became King of England and married Emma, Ethelred's widow. Her two sons, Edward and Alfred, were exiled to Normandy. When Canute died, his son Harold became king and Emma retired to Winchester. Many, including Emma, still felt that Edward was the rightful heir to the throne and that Harold was a usurper.

Emma's sons decided to journey to England and perhaps infiltrate Harold's court. With a large retinue they visited their mother before continuing to London. Emma did not trust Harold and persuaded Edward to remain with her while Alfred went to London with a troop of 600 Norman soldiers.

They broke their journey in Guildford where they were billeted for the night. The events of that night were something the town of Guildford would prefer to forget. Prince Alfred and his retinue were all savagely massacred during the night. The reason for this ghastly event is obscure, but Emma was sure that King Harold was responsible. The victims were flung unceremoniously into the Saxon cemetery and the later excavations revealed the horrendous injuries they had received.

Harold died without an heir in 1040 and for two years there was turmoil in the county until it was eventually agreed that Edward should become king as there was no other suitable heir. A period of relative calm followed and, as Edward the Confessor had no children, he nominated William of Normandy as his successor. He persuaded the Saxon Harold, who felt *he* had a claim to the throne, to swear to support William.

When Edward died in 1066, Harold broke his oath and claimed the throne. William invaded, defeated Harold and became the first of the Norman kings. To consolidate his rule and to dominate his Saxon subjects, he built a fortified castle on a hill. This was the first of the Norman castles to be built in England.

Over the next few centuries, Guildford continued to expand. With the introduction of the wool trade in the twelfth century, it became a wealthy town popular with the reigning monarchs, who visited frequently. In the thirteenth century Henry III visited Guildford so often that he decided to transform the 'castle' into a luxurious 'palace' where he, his family and the Court could stay. He also granted the borough its first charter in January 1257. It was created the County Town of Surrey as it now had the honour of holding the County Court and Assizes.

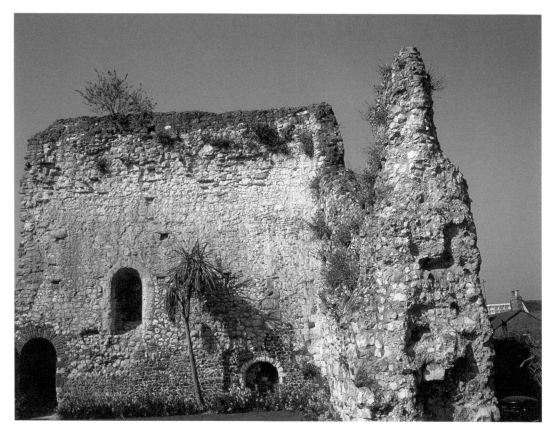

Guildford Castle.

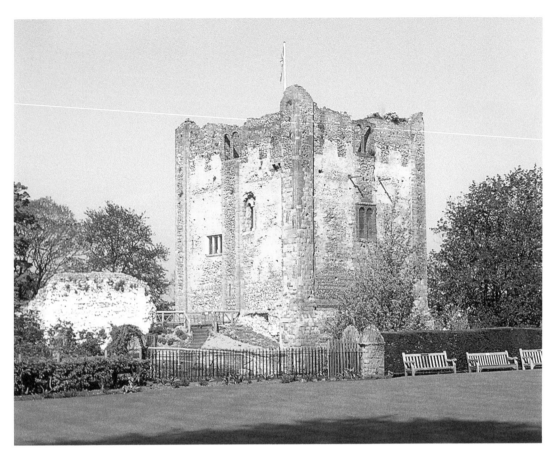

The castle.

In 1485 Guildford was given its own coat of arms by Henry VII. This incorporated the castle, Tudor roses and the Lion couchant to symbolise the royal connection. The town continued to grow with three markets held each week, including the cattle market which dominated the High Street.

When, in the seventeenth century, Portsmouth became a naval base, the inns in Guildford did a flourishing trade as the town was an excellent place to stay on the way to London. The following century saw more developments. The wool trade had decreased and the mills were converted to grind wheat. The Wey Navigation had been completed in 1653 when 9 miles of canals had been dug. This enabled the town to build up a thriving corn trade.

In 1801 a census was taken of the whole population. This was the first one to be held since the Domesday Book of 1087. It showed that the population of Guildford was 2,634. Traffic through the town increased and, in 1825, Quarry Street was widened to accommodate it. To do this, it was necessary to shorten the chancel of St Mary's Church. Tradition suggests that it was George IV who instigated this so that his coach could pass easily along Quarry Street on his way to Brighton and his famous pavilion.

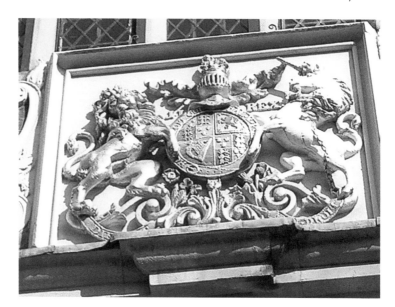

Right: Guildford's coat of arms.

Below: St Mary's Tower.

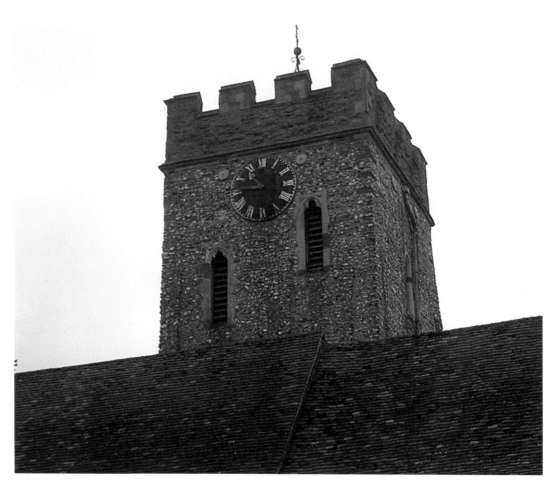

At the beginning of the nineteenth century Guildford was lit by oil lamps. In 1824 gas was introduced and, in 1891, an electricity supply company was formed. Guildford kept up with the times. By the middle of the nineteenth century it also had a small police force whose members wore frock coats and top hats.

The town had always been concerned about the poor in its town. In the seventeenth century George Abbot had founded a 'hospital' to care for them and later three workhouses had been established; a fourth was opened in the nineteenth century. The Royal Surry County Hospital to cater for the growing population was opened in 1866.

With the coming of the railway to Guildford in 1845, coach travel diminished. Mail was sent by train instead of coach and coach services eventually ceased. Rail travel encouraged more visitors and a number of 'Guides to Guildford', produced on the new printing press, extolled the delights of the town.

It was not only tourists who were attracted to Guildford. The railway proved an excellent selling point. One guide informed its readers that 'the most ancient Borough of Guildford, the County Town of Surrey is most advantageously and delightfully placed on the banks of the River Wey'. Wealthy businessmen built elegant mansions on the outskirts of the town and moved in with their families. Commuting to London was easy and at weekends they could enjoy the beauties of the surrounding countryside.

Retired men and women also made Guildford their home and the population continued to grow. The town bid farewell to its medieval past and welcomed the modern world.

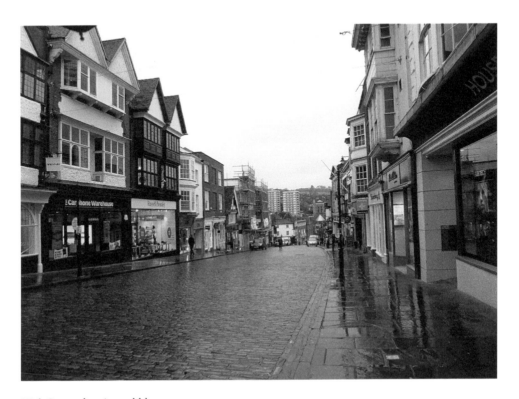

High Street showing cobbles.

The uneven High Street was replaced with granite sets; the cobbled street is still there today. More churches, roads and bridges were built, creating an attractive Victorian town. When the next census was taken in 1901, the population had swollen to nearly 16,000. It was depleted after the First World War when around 500 of its sons gave their lives for King and Country. However, the population grew rapidly after that time, and by 1938 it stood at 42,000. When in the 1940s London was bombed during the Blitz, many inhabitants left the capital for safer areas. Guildford's population soared to nearly 50,000. Only a few bombs were dropped on the town, sparing it the devastation suffered by other places.

Guildford continued to attract more and more visitors after the war. It was surrounded by beautiful countryside, it had a fascinating past, and it had a theatre and sports facilities. In 1961 Guildford Cathedral was consecrated on Stag Hill and in 1966 the University of Surrey, beside the cathedral, was granted a royal charter.

Over the centuries Guildford has been plagued by floods and the twenty-first century started with the worst floods since 1968. Rain fell continuously and the River Wey burst its banks, flooding the nearby Yvonne Theatre. The rest of the area was under water and the situation was so bad that the police closed all the roads leading to the town.

However, Guildford is resilient and once again repaired the damage. No doubt there will be more floods but Guildford will survive and will continue to welcome its many visitors from around the country and from overseas.

The war memorial.

2. The Royal Connection

When Canute, the Viking, defeated the Saxon King Ethelred at the beginning of the eleventh century, the Vikings had come to stay. In 1016 Ethelred died and Canute became King of all England, consolidating his position by marrying Emma, Ethelred's widow. Her two sons, Alfred and Edward, were exiled to Normandy. After Canute's death in 1035, his son Harold became King and Emma retired to Winchester.

Guildford's first documented connection with royalty is one the town would prefer to forget. Soon after Harold became king, Alfred and Edward travelled to Winchester to visit their mother. They were invited to visit Harold in London. Emma did not trust the Viking king and she felt that Edward, her eldest son, was the rightful King. She allowed Alfred to go but kept Edward in Winchester. She was right to do so.

Earl Godwin, the king's representative, escorted the prince with his 600 Norman soldiers to Guildford, where they were to rest before continuing their journey. They never left Guildford! During the night the soldiers were dragged from their beds and brutally slaughtered. The young prince was tortured, blinded and later died from his injuries. This massacre was well documented but the reason for it remains obscure, although Emma had no hesitation in blaming King Harold.

He died in 1040 leaving the country in turmoil but eventually Emma's son Edward, later known as 'The Confessor', was crowned King in 1042. He remembered his Norman heritage by nominating William of Normandy as heir to the English throne. Earl Godwin's son, Harold, was sent to Normandy to swear allegiance to William as heir.

When Edward died in 1066, Harold broke his oath and seized the throne. William invaded, defeated Harold and was crowned King in Westminster Abbey on Christmas Day 1066. It was in Guildford that William decided to build the first castle in England. From it he could dominate the town by garrisoning his soldiers. The work started soon after the coronation.

A circular ditch was dug first; the earth was flung into the centre to form a large mound known as a 'motte'. On this a tower, which would be used as a lookout, was erected. A bridge over the ditch led to the 'baileys', an area of 6 acres. The king's residence was in the 'inner bailey' while the 'outer bailey' housed horses and other livestock.

Guildford, meanwhile, had become a wealthy town as a result of its prosperous wool trade, so the castle became a palace rather than a fortress. Successive kings visited and in the twelfth century a great hall was built within the bailey to accommodate the king and his retinue. Stag Hill, on the north side of the Hog's Back, was populated by deer and in 1155 Henry II made it into a royal park where he and his successors could hunt stags.

King John loved Guildford and visited the town nineteen times. In 1199 he celebrated Christmas in the castle in luxurious style. Aware of Guildford's wealth, the king commanded the 'Approved Men' 'to provide with arms and horses twenty men of the

better sort ... to be ready to go ... on the King's service when so ever he should call them forth'. Towards the end of his reign, he processed through the town on several occasions. His last visit was in October 1216.

The Barons, by now, were thoroughly disillusioned with him and sought help from King Louis of France who sent his son, the Dauphin, across the Channel. He travelled to Guildford Castle where his followers did a great deal of damage. John died in October 1216 and his nine-year-old son Henry ascended the throne. The French invaders were expelled and Guildford entered a calmer period.

Henry III was very attached to Guildford and in 1251 he set up three new mills in the area. He reigned for over fifty years and during that time he visited the town over 100 times. In January 1257 he granted Guildford its first charter and in the same year the town was given the honour of holding the county Court and Assizes.

The castle was transformed into an even more luxurious palace fit for a monarch. Each member of the royal family had a private apartment. The king's walls were panelled in wood while the moon and stars decorated the ceiling. Queen Eleanor had a new 'wardrobe'. Glass, both plain and coloured, was used and murals adorned the walls of the great hall. However, the thrifty monarch informed the 'Sheriff of Surrey [that] the county [should] bear the expense of these improvements'.

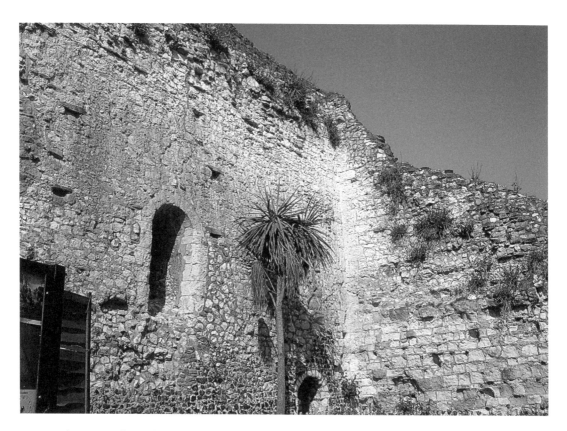

Castle: Queen Eleanor's boudoir, Guildford Castle.

Henry's reign was not without its troubles, and in 1266 there was a rebellion. Prince Edward, Henry's son, captured one of the rebels, Adrian de Gurdon, and incarcerated him in the castle's dungeon before his execution. However, his life was spared after Edward's wife, Eleanor of Castile, pleaded for him. Henry died in 1272. Guildford had been included in the dowry of his widow, Eleanor of Provence, so she gained control of it on his death.

Edward I was not as attached to Guildford as his father had been, so he did not visit very often. He left his small, sickly son, Henry, in the town in the charge of his grandmother. Sadly, the boy died in 1274 at the age of six. His parents were devastated. Eleanor of Provence decided to found a Dominican friary in Henry's memory. The actual date of the foundation is not known.

There was already a small friary building in Guildford and this was enlarged and renovated. The king presented four oak trees 'fit for timber' that could be used for fuel. In return, the friars repaid their royal benefactor by 'trimming and fashioning grounds and gardens about the King's Palace'. Prince Henry was buried in Westminster Abbey but his heart remained in the friary chapel. Every year on the anniversary of his death it was 'solemnly exposed' so masses could be said for the repose of his soul.

Edward I died in 1307 and his son became Edward II. Although a weak king, he left his mark on Guildford. In 1308 he granted a charter that enabled St Catherine's village in the parish of St Nicolas to hold an annual fair on 4 October. A clause within the charter gave all inns within the parish the right to sell beer without a licence on the Sunday before the fair. This became known as 'Tap-up-Sunday' and was greatly appreciated by the villagers.

The facilities in the castle had deteriorated and the friary became the royal residence when the king visited the town. In 1327 Edward II abdicated and his son, Edward III, reigned for fifty years. In 1341 he granted Guildford the right to hold an annual livestock fair in the High Street in May. He visited Guildford little and the castle continued to deteriorate.

Henry IV occasionally visited the town but stayed at the friary. His followers often caused damage and in 1403 a gift of forty shillings was left 'to cover the damage done to the house, vessels and gardens'. His successors visited Guildford rarely but Henry VII was impressed with the town and presented it with its coat of arms. To symbolise the royal connection, it showed the castle, Tudor roses and the lion couchant.

Although his son, Henry VIII, did not visit very often, he 'professed great love and affection for the Friary'. He even built himself a hunting lodge within its precincts. When, in 1537, he ordered the Dissolution of the Monasteries, the friary was converted into a royal residence for the king to use on his visits.

His daughter, Elizabeth also left her mark on the town. In 1586 she granted a charter stating that it was 'lawful for the Mayor and Alderman of [Guildford] on all holidays ... and solemnities, for their greater ornament and honour, to wear gowns made of scarlet cloth'. This was indeed an honour as scarlet was the royal colour.

Her successor, James I, had a more tenuous link with the town. While rarely visiting it, he was very close to George Abbot, Guildford's famous son. Abbot was one of those chosen to join other clerics at Hampton Court in the seventeenth century to produce a new translation of the Bible.

During the eighteenth and nineteenth centuries Guildford became an important staging post on the way from London to the coast. Some roads had to be widened to

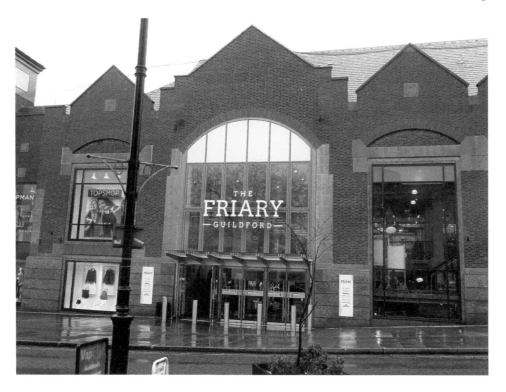

Friary.

accommodate the carriages. One of these was Quarry Street. In 1825 the chancel of St Mary's Church was shortened so that the road could be widened. Tradition suggests that this was done at the instigation of George IV so that his coach could travel easily from Windsor to Brighton to visit his famous pavilion.

Another 'royal connection' is the hospital that opened in Farnham Road in 1866. When Prince Albert had visited Guildford, he had received a rapturous welcome. He had died in 1861 and Queen Victoria was asked if the new hospital could be a memorial to him. She was delighted to agree and the Royal Surrey County Hospital still retains its name today.

The year 1957 was the 700th anniversary of the first charter granted to Guildford by Henry III in 1257 and Guildford celebrated in style. Her Majesty Queen Elizabeth II and her husband drove down the High Street to the accompaniment of church bells pealing out from several churches. The mayor, dressed in ceremonial robes, gave a loyal address of welcome from the balcony of the Guildhall.

The Chamber of Commerce commissioned a new portrait of the Queen. This was presented to the town to celebrate the anniversary and today it hangs in the Guildhall. The royal couple also paid a visit to the cathedral, where a stone on the floor of the nave 'commemorates the visit'. Each of them 'bought a brick' to contribute to the building of the new cathedral.

On 3 April 2006 the Queen paid another visit to the now completed cathedral. On this occasion she distributed Maundy money to a number of local pensioners. It is hoped that Her Majesty will pay more visits to Guildford in the future.

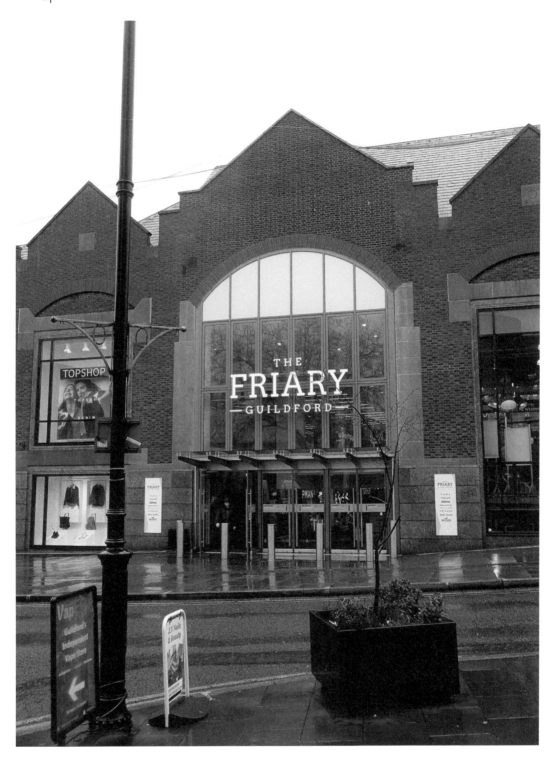

Friary Shopping Centre.

3. Interesting Residents

George Abbot

George Abbot is one of Guildford's most distinguished sons. His family originated in Suffolk but in the thirteenth century they moved to Surrey. It was Maurice Abbot, George's father, a clothier, who moved to Guildford. On 30 June 1548 he married Alice Marsh at St Mary's Church in Quarry Street. They set up home in a cottage near the bridge over the River Wey. Five sons were born, of whom George was the fourth.

There is an interesting legend connected with George's birth. While his mother was pregnant with him she dreamt that if she ate a pike during her pregnancy, the child would become famous. One day, to her surprise, she discovered a pike floating in the bucket of water she had just drawn from the river. Remembering her dream, she cooked the fish and ate it. There is no doubt that George, born in 1562, became famous and is still remembered

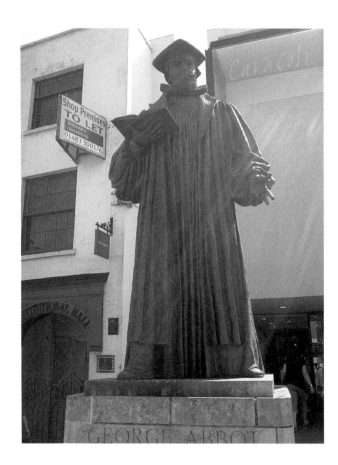

Statue of George Abbot.

today. He was baptised soon after his birth in nearby St Nicolas's Church. Later, the family moved to the other side of the river in the parish of Holy Trinity Church at the top of the High Street. Perhaps influenced partly by the legend but also recognising the boy's potential, three wealthy businessmen sponsored George's education and he was awarded a free place at the Royal Grammar School. Here he distinguished himself, showing a particular aptitude for ancient languages, which were vital to the understanding of the Bible. He even studied Aramaic, the language that Christ himself spoke.

In 1579, he entered Balliol College, Oxford, obtaining his degree in 1582. The following year he became a Bachelor of Theology and five years later, in 1599, a Doctor of Divinity. In September 1599 he was elected the Master of University College, Oxford, and, as the new century dawned, he became the Vice Chancellor of Oxford University.

He also became involved in church affairs and on 6 March 1600 he was installed as the Dean of Winchester Cathedral. He met the new king, James I, who was very impressed with him and often took his advice on theological matters. As now king of both Scotland and England, James wanted to unite the two churches. However, the Presbyterian Scots were wary of a return to Roman Catholicism. They felt that consecrating bishops, as James wished, was the first step towards this. Abbot, however, was able to convince them that the English Church, too, had no desire to return to Rome. Thirteen Scottish bishops were therefore duly consecrated.

To further the union of the Church, James decided to commission a new translation of the Bible which would be available for everyone. In 1603 clerics from both sides of the border were summoned to Hampton Court to start on this great work. George Abbot was one of those selected. His linguistic abilities were put to good use. He worked on the Gospels, the Acts of the Apostles and Revelation but he did not neglect his church duties. In 1609 he was consecrated as Bishop of Coventry and Lichfield. The new translation of the Bible was eventually completed and it was published in 1611. In May of the same year George Abbot was enthroned as Archbishop of Canterbury.

The new Archbishop, however, had not forgotten his roots and he was determined to do something to help the poor of Guildford where he had been brought up. In 1618 he decided to open a hospital which would be a gift to the people of the town 'out of my love to the place of my birth' (At this time a 'hospital' was a place where the poor and the sick could be cared for.). The foundation stone was laid in 1619 and it was completed in 1622. It was to be called the Hospital of the Blessed Trinity and James I issued a Royal Charter. A service was held in the chapel to celebrate this (There is more about Abbot's Hospital in Chapter 6.). Abbot continued to be very attached to his native town, but his clerical duties often kept him away from it and he spent much of his time in his palace in Croydon. His health was starting to fail and in 1621 he visited his friend Lord Zouche, at Bramshill House in Hampshire, to convalesce. While there, the archbishop consecrated the new chapel that had recently been added to the house. A few days later something happened that cast a shadow over the rest of Abbot's life.

He had been invited to join a hunting party and, armed with a crossbow, he set off. Unfortunately, his aim was poor and he accidentally shot Peter Hawkins, a gamekeeper. Although the wound was slight, lack of efficient medical treatment caused the poor man to bleed to death very quickly.

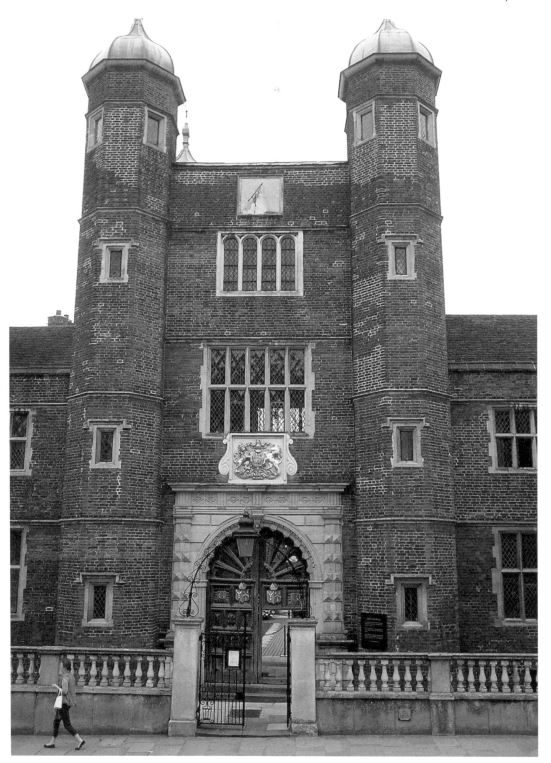

Abbot's Hospital.

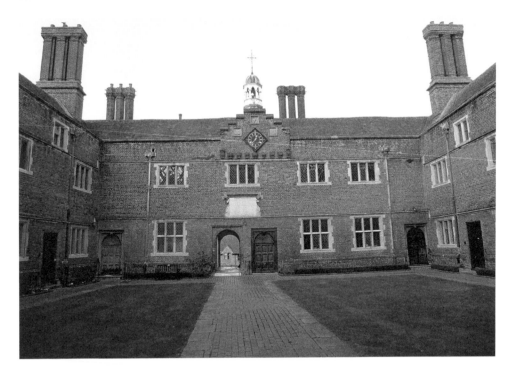

Abbot's Hospital.

Anniversary of King James' Bible.

Those jealous of Abbot's ride to power immediately accused him of murder and demanded that he be stripped of his office. Abbot was devastated and retired to Guildford to await the king's decision. Although there had been disagreements between them, James decreed that the incident had been a tragic accident and Abbot's name was cleared, but he would never forget that he had taken a man's life.

His health continued to deteriorate and, with the advent of a new king, Charles I, he played little part in Church affairs. On 4 August 1633 he died, aged seventy-two, at his palace in Croydon. His will stated that he wished to be buried in Guildford 'in the same town where my flesh had the beginning'.

His state funeral, on 3 September, began in Croydon and his body was transported to Guildford where crowds followed his coffin to Holy Trinity Church where he was buried in a magnificent renaissance tomb commissioned by one of his brothers, Maurice. The tomb was completed in 1635.

Lewis Carroll

Charles Lutwidge Dodgson was born on 27 January 1832, the eldest son of eleven children of a country parson. When he was eleven, the family moved to a large vicarage in Yorkshire. At first Charles was educated at home and read widely. He later attended Richmond Grammar School and in 1946 he went to Rugby School, which he did not enjoy although he excelled at academic work. He became a brilliant mathematician and in 1851 he went to Christ Church College, Oxford, to study that subject.

That year his mother died and her sister, Lucy Lutwidge, went to Yorkshire to care for the bereaved family. Charles remained in Oxford and in 1854 he achieved a first class honours degree in mathematics. The following year he won the Christ Church mathematical lectureship and remained in that post for the rest of his life.

Oxford at that time required all lecturers to become ordained. Charles resisted this as he had a stammer and was embarrassed about preaching in public, although he was happy lecturing to his students. He was eventually persuaded that he had to obey the college rules if he was to stay in his post and he was ordained a deacon on 22 December 1861. However, he never took the final step of becoming an ordained priest (most deacons serve a probationary year before attending a second service where they become ordained as a priest).

While in Oxford he became a member of the pre-Raphaelite social circle and during this time he wrote poetry and stories, some of which were published. He adopted his famous pseudonym, Lewis Carroll. He also wrote a number of mathematical books under his own name. In 1856 Henry Liddell became dean of Christ Church and the young lecturer became very friendly with the family. At his time he became interested in the new art form of photography and his took a number of excellent photographs of the Liddell children. He also took them rowing.

It is probably during this time that the seeds for Carroll's most famous books were sown. He told stories while rowing and it is likely that it was Alice Liddell who was the model for his first book *Alice in Wonderland*. He first wrote the story by hand for Alice, entitling it *Alice's Adventures Underground*; it was published in 1865 as *Alice in Wonderland*. It was a great success and the author received much fan mail. A realistic

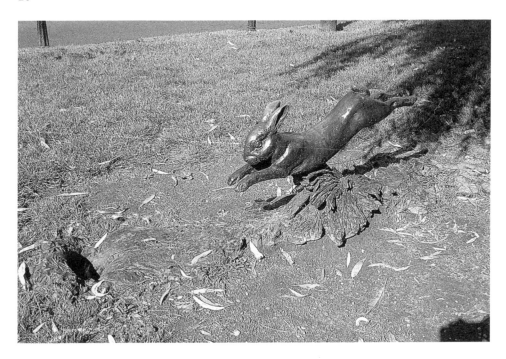

The rabbit hole.

statue of Alice and her sister lies on the banks of the River Wey in Guildford. In front of them is the White Rabbit running towards his rabbit hole.

In 1868 the Revd Lutwidge Dodgson died and, as the eldest son, Charles was now responsible for his aunt and sisters. New accommodation was required. Charles was no stranger to the railway and used it frequently. A number of his friends had recently moved to Guildford, the county town of Surrey, and in 1868 he and an artist friend, Walter Anderson, travelled by train to Guildford to house-hunt.

They found a suitable house on Castle Hill. The Chestnuts, built in 1866, was so-called because of the avenue of chestnut trees lining the entrance to the house. The Lutwidge-Dodgsons moved in later that year. Charles continued to live in Oxford but he frequently visited The Chestnuts to stay with his aunt and six unmarried sisters. He always spent Christmas in Guildford.

He became very attached to the town, going for long walks over the Hog's Back. On one occasion the idea of his poem 'The Hunting of the Snark' popped into his head. During the Christmas period in 1968 he wrote the first chapter of the sequel to *Alice in Wonderland*. He completed *Alice Through the Looking Glass* during his Christmas visit to The Chestnuts in 1871 and it was published, to great acclaim, the following year.

Lewis Carroll had many friends in Guildford and he often visited Miss Edith Haydon, who lived in Castle Gate, a house in the castle grounds. In 1990 a student at the Guildford Adult Education Institute, Jean Argent, was inspired by Alice's visit to 'Looking Glass Land'. She created the most beautiful statue of the little girl going through the 'Looking Glass'. This now stands in the garden of Castle Gate.

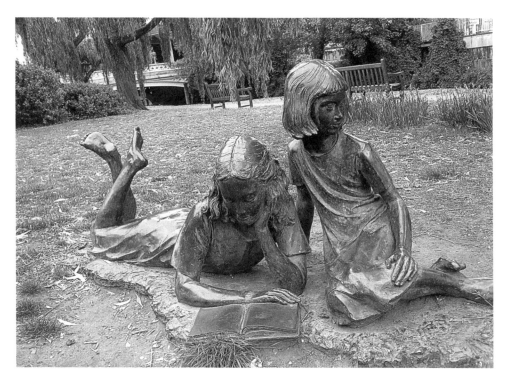

Above: Alice and sister on riverbank.

Below left: Alice through the Looking Glass.

Below right: Through the Looking Glass.

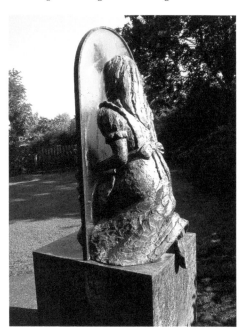

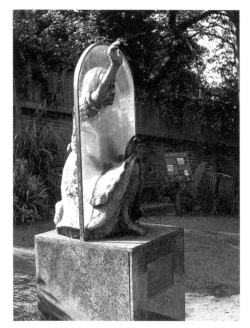

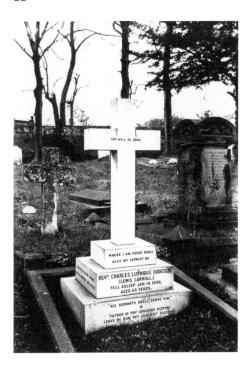

Lewis Carroll's grave.

Because of his stammer, Dodgson had always rejected requests to preach in Guildford, but in 1887, his objections were overruled and he preached in St Mary's Church for the first time. Having overcome his reluctance, he then preached there once or twice a year over the next ten years.

In 1897 he made his last Christmas visit to The Chestnuts. While there, he caught influenza, which affected his lungs. On 14 January 1898 he died at the age of sixty-five. The current dean of Christ Church College took the simple funeral service at St Mary's. His coffin, followed by his sisters and other mourners, was carried to the Mount Cemetery where he was buried.

His remaining sisters continued to live in The Chestnuts until the last sister died in 1920. The house then reverted to the landlord as it had been rented, as was the custom at that time.

Henry Peak

Henry Peak, the son of a gilder, was born in London on 18 February 1832. He enjoyed his schooldays: 'In 1844, much to my delight I was sent to a good school for Boys'. In many of the subjects, he was 'soon top of the class … As to drawing … this being my natural bent, I excelled almost all the boys'. His classmates made use of his talent and he was soon in trouble for doing their work for them.

His father recognised his talent for 'lithography engraving or the like' but unfortunately, 'the premium required' for his son to apprenticed was 'beyond his means'. Henry eventually found work with a printer and, at the same time, he taught himself an architect's craft as he wished to pursue 'the profession of an Architect or Surveyor'.

When he was nineteen, he was offered a job in Guildford as an assistant to Moss, a builder with an office on the Portsmouth Road. Travelling by train the 30 miles to his new post, he was most impressed with the new railway system. His new employer was 'a short, fat, bald, bespectacled man' who had little education but 'possessed great practical knowledge'.

Peak found lodging in Commercial Road with a Mrs Nye, whose niece, a teacher, was staying with her. The two young people fell in love; they were married in London on 17 June 1856 and returned to Guildford where they rented a house in Stoke Fields. Mrs Nye moved in with them and Mrs Peak gave up work to help her husband, who was still studying to become an architect. In 1858 they moved to a larger house in Commercial Road where Peak used one of the rooms as an office. He learnt a lot from his employer for whom he worked for seven years.

When Moss's business collapsed because of a failed building venture, Peak decided to set up on his own. This was not easy as the local traders were a close-knit group and did not welcome 'foreigners'. However, he persevered and was rewarded when, in 1862, a local doctor, Thomas Sells, commissioned him to design a new suburb in the parish of Holy Trinity Church. Catering for both rich and poor, villas were built for the rich and small cottages for the poor. The suburb was self-sufficient, boasting a school, shops and three public houses. The small chapel, known affectionately as the Tin Tabernacle, was constructed of green corrugated iron. This became the centre of the community and

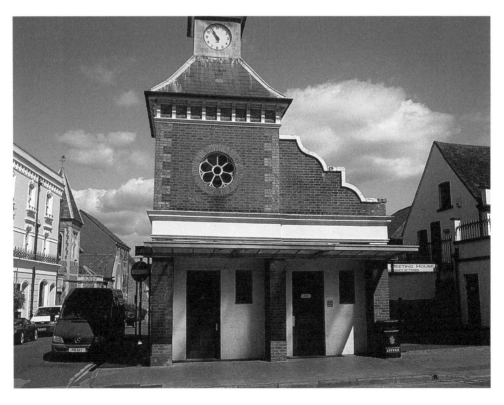

Fire station.

remained so until 1967 when it was demolished. The new suburb was named Charlotteville after Thomas Sells' wife and all the roads bore the names of famous medical practitioners. Today it is a conservation area.

Peak's ability was soon recognised and, in 1864, he became the first Borough Surveyor. He held this post for twenty-eight years and, during this time, he modernised Guildford. His pay was poor and he often financed his projects himself. In 1872 fire precautions in the town were rudimentary and Peak designed a new brick fire station setting the scene for a more professional fire service.

More commissions followed. Peak designed churches, houses, roads, bridges and cemeteries, many of which can still be seen. As a Special Constable, Peak had complained about 'parading the damp and dismal streets for hours'. He decided to do something about this. He replaced the medieval High Street with the cobbled street that is still in use today.

In 1899 Peak was elected mayor, but he objected to the lavish banquet that followed the inauguration – he had always lived frugally. In spite of his humble beginnings, he had trained himself to become one of the most prolific architects of the nineteenth century and his work is still appreciated by Guildford residents today.

Park.

Bowling green and war memorial.

Joseph Billings

In 1843 Joseph Billings bought a printing firm for £450 from Benjamin Bensley. It was situated in Woking but by 1856 it had outgrown its premises and Billings moved his firm to Guildford. He bought a store warehouse on the Railway Esplanade near the station. Nearby, he built himself a house and named it Coverdale. His firm flourished and before long he had ten printing presses. The installation of steam power in 1860 sped up the production of books.

His two sons, Joseph Harrild and Robert Thomas, joined the firm to learn the printing business. In 1875 they were made partners. Harrild, the elder, was responsible for the composition while his younger brother, Robert, oversaw the machine room and foundry.

Billings printed a variety of books. They produced novels, literature, educational books and works on religious and medical topics. Over 1,000 copies were produced for each title. The exception was *East Lynne*, the best-selling novel by Mrs Henry Wood. This print run reached 15,000.

More extensions were made to the factory in the 1870s and in April 1880 another warehouse was acquired and renovated. In 1882 Joseph Billings retired but, as he was still living in Coverdale, he was always available to give advice or lend a hand if necessary.

At the beginning 1897 another partner, Maurice Lacy, joined the company. When in 1899 yet another extension was needed, Henry Peak, the County Surveyor, was employed to supervise it. This was a large addition to the printing press known as the 'jobbing room'.

The twentieth century saw more extensions and electricity replaced steam. During the First World War much paper was pulped and valuable first editions and records were lost. In 1936 Bertram, Harrild's son, became chairman of the company. He retired in 1962 and the company was taken over by an 'outsider', Alfred Owen. He continued the modernisation of the company until, in 1964, it was amalgamated with Unwins and later became a subsidiary of Blackwell Press.

Ernest Shepard

Ernest Shepard was born in London on 10 December 1879. His father was an architect and his whole family was interested in the arts. Ernest showed an early aptitude for drawing and in 1897, he won a scholarship to the Royal Academy where he studied painting and sculpture. While there, he met his wife Florence, whom he married in 1904. They moved to Guildford where he lived for the next fifty-one years, forming a great attachment to the town.

After he left the academy, he became a prolific book illustrator and also drew cartoons for *Punch*. He met A. A. Milne, the author of the *Winnie the Pooh* series of books. While, at first, the author was not impressed with Shepard's work, he soon changed his mind and realised that this illustrator would be perfect for his books. Shepard visited Milne's home and sketched the author's son, Christopher Robin, and also the boy's soft toys. However, it is likely that 'Growler', the teddy bear belonging to Grahame, Shepard's son, was used as a model for Winnie the Pooh.

When the First World War started, Shephard joined the Royal Artillery. He was promoted to captain in 1917 and discharged as a major in 1919. After the war, he continued to work for *Punch* and in 1921 he was made a senior staff member. He met Kenneth Grahame, the author of *The Wind in the Willows*, and it was not long before Grahame commissioned him to illustrate his books. Shephard's illustrations of these famous books assured his lasting fame as an illustrator.

Sadly, his wife died in 1927 but Shepard continued to work. He moved from Guildford in 1955 but he always retained a great affection for the town. He spent the latter days of his life in Midhurst in Sussex. In 1974 he visited Surrey University. With him, he carried a number of his drawings, manuscripts, diaries, papers and other memorabilia. These he presented to the vice-chancellor, saying that he felt they rightfully belonged to the university in Guildford where he had done so much of his work. The archivist was delighted with them and created a separate section in the archives for this unique, valuable collection.

Shepard died on 24 March 1976, stating in his will that no biography of him should be written until thirty years after his death.

Sir Edward Maufe

Although Sir Edward Maufe was not a Guildford resident, he played such an important role in the creation of Guildford Cathedral that he merits inclusion in this chapter. Sir Edward's family name was Muff and he was born in Yorkshire in 1882. He attended Wharfedale School in Ilkley and in 1899 he went to London as an apprentice to study architecture under William Pite.

During this time his family moved to Bexleyheath where they lived in the Red House designed by Philip Webb. This design greatly influenced the budding architect's future work. In 1904 he entered St John's College, Oxford, and was awarded a BA in 1908. The following year he changed his name to 'Maufe' by deed poll.

In 1910 he married Prudence Stutchbury, who was a designer and interior decorator. He set up his own practice in 1912. His first major commission was to design Kelling Hall in Norfolk for Sir Henry Deterling. The First World War halted his work for a time and it was not until 1920 that he was elected a Fellow of the Royal Institute of British Architects. He continued to design and build houses, company buildings and places of worship. He became the principal architect UK to the Imperial War Graves Commission and in 1944 he was awarded the Royal Gold Medal for Architecture. In the 1950s he designed the Air Forces Memorial at Runnymede and in 1954 he received a knighthood.

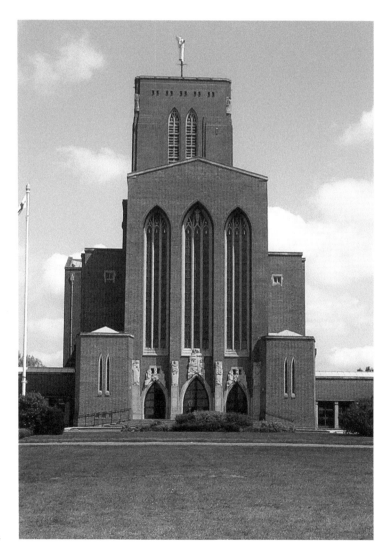

Guildford Cathedral.

However, it is for Guildford Cathedral that Sir Edward will be mainly remembered in this town. He was nearly fifty when the newly created Diocese of Guildford decided that a cathedral should be built on Stag Hill and invited architects to send in their suggested designs for the new building. On 23 July 1032 it was announced that Maufe had won the competition. He and his family were delighted and his granddaughter remembers that from that time the 'cathedral' was always the main topic of conversation. Maufe felt that the site was 'providentially made for a cathedral' as it should 'grow naturally without effort out of Stag Hill itself'.

As a designer herself, his wife had always been a great help to her husband and she worked enthusiastically beside him on his new project. They both felt that the new cathedral 'should be a symbol expressing the Christian Creed in all its parts'. As a director of Heal's Furniture store, Prudence was responsible for the furnishings in the cathedral. She also designed the vestments and the kneelers. However, the carpet below the steps leading up to the High Altar was designed by her husband. The Cathedral of the Holy Spirit was finally dedicated on 17 May 1961.

Sir Edward continued to write and lecture on architecture until he retired in 1964. He died on his ninety-second birthday, on 12 December 1974. His wife followed him two years later.

Hassocks.

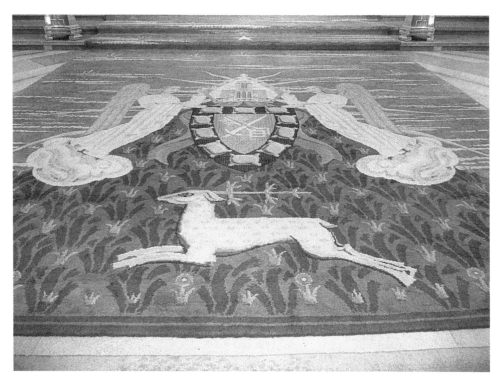

Altar carpet.

Alan Turing

Alan Mathison Turing was born on 23 June 1912 in Cheshire. His father worked for the Indian Colonial Service, but when he retired in 1927, the family moved to Ennismore Avenue in Guildford. This provided Alan with his first proper home and he was always attached to the town that had nurtured him. From a very early age he showed the intelligence that would prove so instrumental in shortening the Second World War.

At the age of thirteen he went to Sherborn School in Dorset where he showed an interest in maths and science. He was a keen athlete and could often be seen jogging around Guildford during the holidays as well as walking in Stoke Park and on the North Downs. He also spent a great deal of time in the garden of his home gazing at the stars and drawing the night sky. When his parents separated, his mother eventually settled in South Hill. His father died in 1947 and was cremated at Woking Crematorium.

In 1931 Alan went to King's College, Cambridge, where he achieved a first class honours degree in maths, and in 1935, at the age of only twenty-two, he became a Fellow of King's College. The following year he went to Princeton University in the United States and spent two years there.

Returning to England, he continued to visit his mother often, even running the 18 miles from his home in Hampton to Guildford! He became a member of Walton Athletic Club and showed great prowess as a marathon runner.

When war broke out in 1939, Turing's intelligence and talents were soon recognised by the government and he was sent to Bletchley Park – the code-breaking centre. Here, he created his 'Bombe', an ingenious logic engine which sped up the breaking of German cyphers. The Germans used their Enigma encoder to encrypt secret messages, but Turing was able to intercept their coded messages. There is no doubt that this was instrumental in helping the Allies defeat the Nazis and perhaps shortened the war by two years. In 1945 Alan Turing was awarded an OBE for his work.

After the war he worked at the National Physical Laboratory, helping to develop computers. He continued to visit his mother in Guildford and would often walk around the town with her discussing his projects. His last visit was at Christmas in 1953.

Sadly in 1952, he was prosecuted for homosexuality. As an alternative to prison, he accepted the very unpleasant 'chemical castration'. This upset him and in 1954 he died of cyanide poisoning. At the Inquest it was decided that he had committed suicide. Like his father, he was cremated at Woking Crematorium and his ashes were scattered near those of his father. A statue of him was later erected in the grounds of Surrey University.

In 2009, Prime Minister Gordon Brown issued a public apology for 'the appalling way [Alan Turing] was treated'. In 2013 the Queen granted him a posthumous pardon.

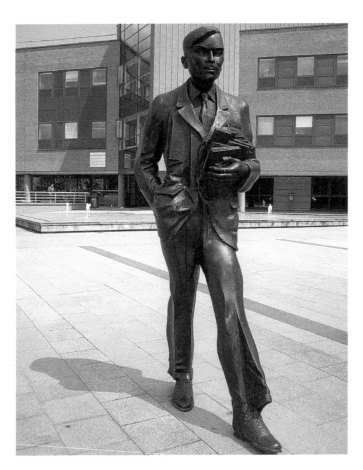

Statue of Alan Turing.

4. The Royal Grammar School

In the thirteenth century a Dominican friary was founded in Guildford. It is likely that boys who joined it would be been given some form of education, although it would have been mainly religious; some Latin and Greek may have been taught. The friary was small with never more than twenty friars, but there is little recorded about education in Guildford at this time.

Then in 1509 Robert Beckingham, a wealthy merchant, died. Although he did not live in Guildford, he was friendly with Thomas Polsted who lived in Stoke Parish and both were aware of the lack of educational facilities in the town. In his will Beckingham made money available 'to make a free school at the Town of Guildford'. His executors, among whom was Thomas Polsted, were to use the money for maintaining the new school and paying the master.

The land Beckingham owned in Kent and Surrey was transferred to the mayor and approved men. The rent from the land, which would be paid annually, was to establish the school. On 4 May 1512 a trust deed established a 'free school' with six pupils and one teacher. It also invested the mayor and approved men with 'the duty of ever afterwards maintaining the school'. This group had been created by Royal Charter in 1488 and their role was to run the town. There were no instructions about a curriculum in the deed but it stipulated 'that there shall be a sufficient school master there always from henceforth to keep the said school and freely to teach all children being in the same school'.

It is likely that the teachers would have been the friars and they may not have been paid a salary as teaching was part of their role as Dominican friars. The 'school' was probably first based in the friary. Later it may have been relocated to a house in Castle Street which Beckingham had earlier donated to the town.

In 1520 the mayor and approved men gave to the school some land near the castle on which a schoolhouse and a master's house were built. The thirty pupils moved in and the master was paid an annual salary of six pounds. There were never more than thirty pupils and it is possible that there may have been a few girls. They received a basic education. The friary was dissolved by Henry VIII in 1538 and by that time only seven friars remained. Its name is still retained in the Friary Shopping Centre that opened in 1981.

In his will Beckingham had stipulated that the school should be endowed as a chantry; prayers were to be said daily for his soul and that of his wife. This continued until the new king, Edward VI, dissolved the chantries in 1547 and confiscated their properties. Determined to keep the 'free school', the mayor and his councillors petitioned the king for a charter and funds to retain the school. Their plea was supported by the Lord Chamberlain, the Marquess of Northampton, who was living in Guildford at the time.

To the delight of all, Edward granted a Royal Charter with an annual sum of twenty pounds. On 27 January 1552 the *Schola regia, Grammaticalis Edvardi Sexi* was established 'for the Education, Institution and Instruction of Boys and Youths in Grammar at all future times'. The boys – no girls – would be grounded in Latin grammar and there would be an emphasis on literary culture. A master and a junior teacher, known as an 'usher', would be appointed by the mayor and his colleagues. They would also draw up the school's statutes, which limited the number of pupils to 100.

The schoolhouse, 'a very strong, stately and fair building', was completed but there was no money left to build accommodation for the teachers. However, in the 1560s money was raised from wealthy benefactors and the building of the master's house started. It was to be 'all of bricks of a strong and fair building of three storeys high, covered with Horsham stone'. It was not finished until 1586.

John Austen, a Mayor of Guildford and the local Member of Parliament, was a benefactor of the school. He had created a library, which was later restored by his son George and donated to the school. John Parkhurst, who had attended the school and had been one of its most outstanding scholars, had graduated from Merton College, Oxford, in 1529. He later became Bishop of Norwich and, when he died, he also bequeathed his collection of early printed books to the school. These were so valuable that they had to be chained together for safety. Today the Royal Grammar School possesses one of the few chained libraries in the country.

The school weathered the turbulent times of the Civil War, the Commonwealth and finally the Restoration. Schoolmasters, at this time, had to be politically flexible and there were only three recorded masters between 1603 and 1645. Then John Graile took over. Unusually, he was not a cleric but was related to the Stoughtons, who were large landowners in the area. He remained at his post until his death in 1697 at the great age of eighty-eight!

In 1691 John Nettles, a Guildford corn merchant, died and left money for a scholarship to be awarded to enable one of the 'scholars' to attend university. If no scholarship was awarded, the next beneficiary would receive the previous year's money as well. The school, meanwhile, needed more money and when John Pearsall became master in 1756, he awarded the Nettles Scholarship to the son of William Savage, a former mayor, although the boy had never been a pupil of the school. Pearsall and Savage were both greedy, unscrupulous men and eventually a court decided that Savage's son was not entitled to the scholarship. Although Pearsall was deemed 'incompetent' in 1759, he remained as master until 1768 while the school declined in numbers and reputation.

Fortunately, his successor, Samuel Cole, was a very different master. Appointed in 1769, he was determined to improve the school; by 1777, he had made such an impact that he was awarded a bonus of £100 'in 'Consideration and as a Compensation for his Diligence, care and Industry in raising [the school] to its Present Flourishing State and Conditions'. He changed the name of the school to the Royal Grammar School – a name it still bears. The narrow curriculum was widened and he even introduced drama; the 'Young Gentlemen', including his son, performed *The Grecian Daughter* in front of the public.

By the time Cole retired in 1804, the number of pupils had increased to sixty and his son replaced him as master. All Guildford boys who passed the entrance examination were entitled to a free education, but the school needed money to maintain its buildings and reputation. It attracted fee payers from elsewhere and by 1818 only ten pupils were receiving free education while the rest from outside the town paid a fee.

During the nineteenth century the school developed under the leadership of capable masters. The curriculum was again widened to include mathematics, French, divinity and history. More staff were employed and extra classes in drawing, drill, music and swimming were also available. Some boys were now boarders who paid for the privilege. In 1863 a chapel was erected in the school garden.

Sport became popular and cricket matches were played against other schools. In the sixteenth century John Parvhish remembered that 'when he was a scholler in the Free School of Guildford, he and several of his fellowes did runne and play there at Crechett and other plaies'. This is the first time the national game had been mentioned in the English language.

By 1867 there were 110 boys of whom only ten were 'free scholars'; there were eighty-one boarders. However, all the boys were either of the 'upper' or 'middle' classes. There were no 'lower class' boys, as John Mason remembered in his *History of Guildford*. His father had applied for his son to attend the school but his application had been rejected as the school was not intended for such men as him.

In November 1888 Royal Assent was given to a Charity Commission Scheme, which established the status of the Royal Grammar School. It was to be a day school with no fewer than 100 boys, preferably those who lived in Guildford. The following year the new governing body advertised for a headmaster. There were 160 applications and John Honeybourne, a Cambridge graduate, was appointed in April to take his post in 'damp, dark and delapidated' premises with only twenty-one boys.

The new headmaster set about improving conditions. The buildings were at last restored and reopened in 1890. There were now fouty-four boys and within four years numbers had reached the stipulated 100. Over the next two years this increased to 120 and remained at that level into the twentieth century. Honeybourne made his mark on the school; it was to be a 'good Modern school to prepare boys for business life and commercial pursuits' while not neglecting prospective university candidates.

In 1890 the government had passed a Technical Instruction Act to encourage teachers of science by allowing local authorities to provide funding for science and technical teachers. The school took advantage of this as its science facilities were severely limited. A science master was appointed but it was not until 1909 that a separate physics laboratory was built. Honeybourne was an excellent headmaster and in 1913 the inspectors praised him for the 'extraordinary care and attention which has consistently given to all the details of [the school's] life and management'.

More staff were appointed, and art and woodwork were added to the curriculum. There were more extra-curricular activities: sports clubs were formed and a cadet corps was established. The school continued to improve during the rest of the twentieth century. The latter part of this century saw considerable social change in the country. Eighteen instead

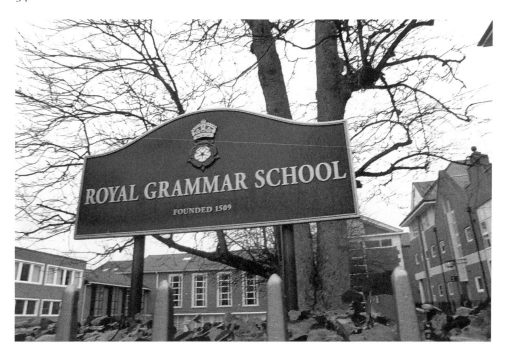

Sign in front of school.

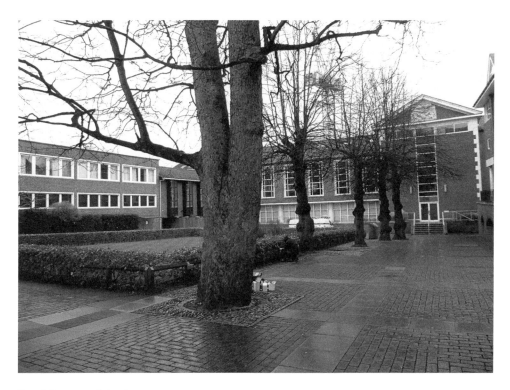

Royal Grammar School.

of twenty-one became the new age of majority. The young were becoming more assertive and student riots took place. The worst of these was in May 1968 in Paris. The 'young gentlemen' of RGS were affected by the changes but in a much less violent way.

There was 'some relaxation' in dress and students were allowed to go into the town during the lunch hour. The 'cap rule' had been challenged some years earlier when Terry Jones, the school captain, had persuaded the headmaster to abolish caps in the sixth form. Terry later became a member of the famous Monty Python team.

The school continued its prowess in sports and in academia. Every year the standard in public exams was high and a number of boys won places at Oxford and Cambridge. In 1972 John Daniel was selected from eighty-six candidates as deputy head. When the current headmaster, Freddie Hore, retired, Daniel took over as 'acting head' of a school that was 'in suspended animation'.

Over the previous few years it had stagnated and numbers had declined. At this time, education in the whole country was in a state of flux with the introduction of comprehensive education at secondary level. Daniel was determined to prepare the school for the future, whatever it held. In 1975 he had a waiting list of 340 boys, many of whose parents were happy to pay fees should the school become independent. He felt that 15 per cent of the intake should be entitled to free places and was determined that the school 'should not become a school solely for the sons of rich people'.

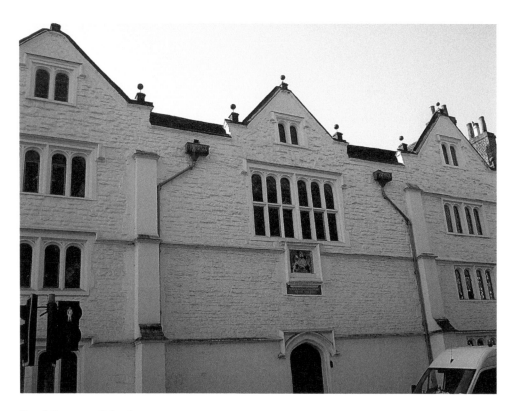

Royal Grammar School.

He also improved the curriculum, divided the day into eight periods and abolished the distinction between the arts and the sciences in the sixth form so that 'mixed' subjects could be taken at advanced ('A') level. The final agreement that RGS should become independent had to come from the Secretary of State. At the end of 1976 John Daniel heard, 'with relief tinged with incredibility', that Shirley Williams had agreed that on 1 September 1977 RGS would become an independent boys' school.

The first day of the 'new' school saw over 600 boys on the roll while over 100 were paying fees. A bursar was appointed for the first time and John Daniel, no longer the 'acting head', worked tirelessly to improve the facilities, teaching standards and the general ethos of the school. He described this time as 'exciting' but 'devilish hard work'. During his tenure he established the excellent reputation of the school, which continues to this day.

When he retired in 1992, a farewell concert was organised involving most of the musicians in the school. He had always encouraged music and he himself played the double bass. He was succeeded in September 1992 by Tim Young, who was 'delighted to take over a school in such excellent shape'. He steered the school into the twenty-first century and today the RGS continues its reputation as one of Surrey's finest independent schools.

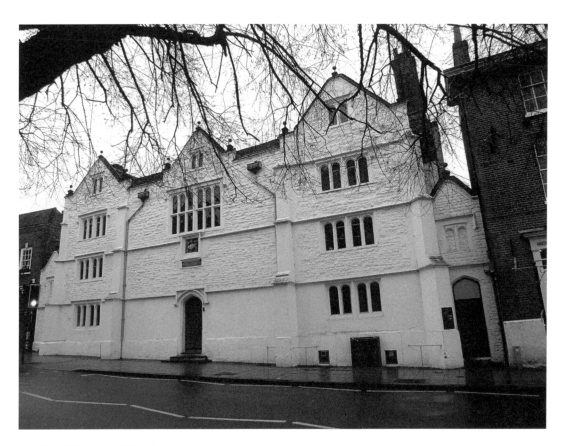

Royal Grammar School.

5. Places of Worship

The Jews

Although Guildford was not one of the towns in which Jews were officially permitted to live, there were definitely Jews living there in the twelfth and thirteenth centuries. They were often wealthy and the tallage land tax, introduced by the Normans, was frequently levied on them. When, in 1187, Henry II needed money to fund a crusade, he took advantage of this. He demanded that they pay 'the fourth part of their goods and chattels towards the expense of a Crusade to Palestine'.

In 1189, Richard I, Henry II's son, also levied the 'Saladin tallage' to help fund the Third Crusade. When Isaac, the son of a Guildford rabbi, refused to pay it, he was fined £200. However, he was permitted to pay in instalments. The amount of £100 was to be paid on the Sunday when Laetare Jerusalem was sung (the 'Laetare Jerusalem' was a chant used as the choir processed into the church on the fourth Sunday in Lent).The rest was to be paid annually in thirty-pound instalments. An extra fifteen pounds had to be paid at both Michaelmas and Easter. King John, in 1210, also took a great deal of money from the Jews using the tallage system.

In 1995 some excavations took place in the High Street in Guildford. Underneath one of the shops, an interesting stone room, 10 feet square, was discovered; a stone bench surrounded the walls and in a crack, the archaeologists discovered a twelfth-century coin. A flight of stairs led to one of the two doorways. Historians believe that this was probably a synagogue constructed as part of a house in 1180. It was demolished around 1290 at the time when the Jews were expelled from England.

The Jews obviously returned to Guildford at some point as today there is a Jewish community in the town. The present Synagogue in York Road was built in 1979. Services are held regularly on the last Saturday of each month. Major Jewish festivals are also celebrated.

The Quakers

Quakers appeared in Guildford during the 1650s. They met to worship in houses and for a while all was well. Then in 1661 Charles II issued a proclamation banning Quakers from holding meetings on pain of imprisonment. As one Quaker wrote later, 'the zeal of the authorities soon filled the goals with Quakers'! Later James II suspended the Penal Laws and gave Quakers the freedom to meet 'provided nothing was preached to alienate people from the King'!

The Quakers eventually decided that it was time that Guildford had a Meeting House in which to worship. A plot of land was bought at the top of North Street. The gatehouse that stood on it was converted to a Meeting House and the rest of the land was used for a burial ground. The Quakers continued to worship there until the beginning of the nineteenth century. In the centre of the area was a large tree under which speakers could address an audience. It was later named Speakers' Tree.

By 1804 the Meeting House had started to deteriorate. Money was raised to build a new one and land was bought in nearby Ward Street. The new Meeting House was completed in 1806 and the first meeting in the new venue was held on 6 February of that year. In the twenty-first century the Quakers continue to worship there holding regular meetings on Sunday mornings.

In 1927 the borough council took over the maintenance of the original site. The derelict building was demolished, the garden was restored and wooden seats were erected for visitors to relax. Today known as Quakers' Acre, it is an oasis of tranquility in the centre of a busy town. A plaque beside the entrance tells the history of the area.

St Mary's Church

It is likely that a timber Saxon church was built on the site of St Mary's Church in Quarry Street. In 1040 it was rebuilt in stone and the Anglo-Saxon tower is the oldest surviving structure in Guildford. One hundred years later St John's Chapel was added to the south side of the church. In 1250 the side aisles were extended and biblical scenes were painted on the walls.

During the fourteenth century a number of windows were inserted to create more light and the beautiful east window was installed in the following century. Because the church was near the castle, the king and his family would worship there during his visits to Guildford.

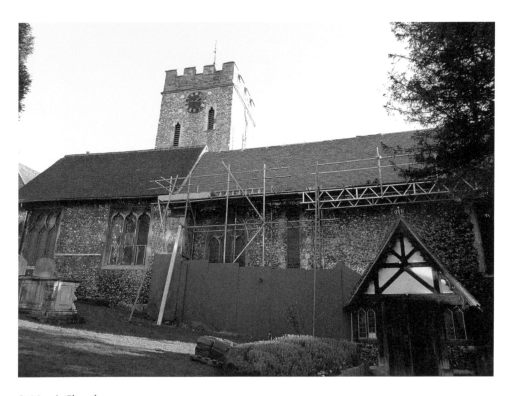

St Mary's Church.

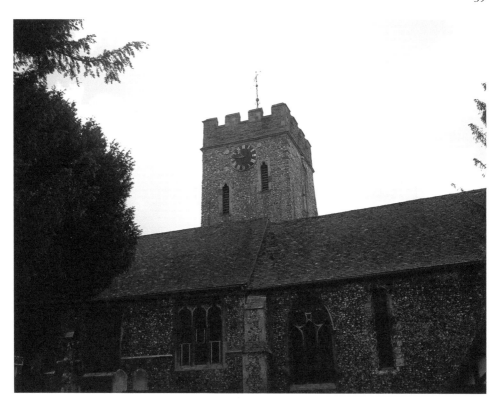

St Mary's Church.

The nineteenth century saw several changes. In 1825 the chancel was shortened so that Quarry Street could be widened. In 1850 the west window was inserted and in 1862 renovations were carried out on the stonework while the gallery was removed. A stone and marble pulpit replaced the original seventeenth-century pulpit. When he visited his sisters in Chestnuts, Lewis Carroll attended the church and sometimes preached there. His funeral service was held in St Mary's in January 1898.

In 1993 St Mary's became a Grade I-listed building. In 1979 an SPCK Bookshop was installed at the western end of the church, but this closed twenty years later in 1999.

The twenty-first century saw a change to church's function. In 2013 it opened its doors to the Guildford Methodist Church and today it hosts both Anglican and Methodist services and is a joint parish with Holy Trinity Church.

Holy Trinity Church

Holy Trinity Church stands at the top of the High Street. A medieval church, possibly of Norman origin, stood on the site until the middle of the eighteenth century. The first rector took office in 1304. In 1540, a wealthy landowner, Richard Weston, built a chapel onto the south side of the church, where he intended to be buried. Known as the Weston Chapel, this was the only part of the building that was not destroyed when the church steeple collapsed in 1740.

A new red-brick building was erected and the first service was held in 1763. During the following two centuries alterations were made to the interior. In 1880 the east end of the church was enlarged. This created space for choir stalls, a sanctuary, a side chapel and an organ chamber. In 1927 a wrought-iron choir screen was erected. The organ was renovated in 1977 and also twenty years later in 1997. The church contains two notable memorials: George Abbot's tomb and a memorial to Arthur Onslow, who was the Speaker of the House of Commons in the seventeenth century.

When Guildford Diocese was created in 1927, Holy Trinity acted as 'pro-cathedral' because the new Guildford Cathedral was not finally completed until the 1960s. For over thirty years the church played its part as the cathedral 'stand-in'.

By 1961 the cathedral was ready for use, although more work still needed. The date 17 May 1961 was decided upon as the day on which it should be consecrated. Sadly, Ivor Watkins, the fourth Bishop of Guildford, had died the previous year. George Reindorp was hurriedly appointed as the new bishop.

On 12 April 1961 Holy Trinity Church hosted its last major event as a cathedral. Bishop Reindorp was enthroned there as the fifth Bishop of Guildford. The following month, on 17 May, he led the service of consecration in the new cathedral in the presence of Her Majesty the Queen.

Today Holy Trinity Church continues to serve the local community and is also the 'Civic Church'. It is here that the new Mayor of Guildford is installed every year and the church also hosts the annual Service of Remembrance.

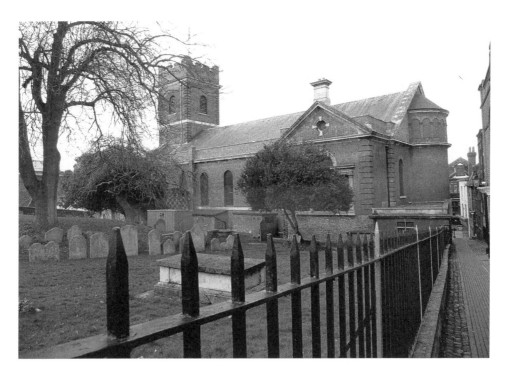

Holy Trinity Church.

41

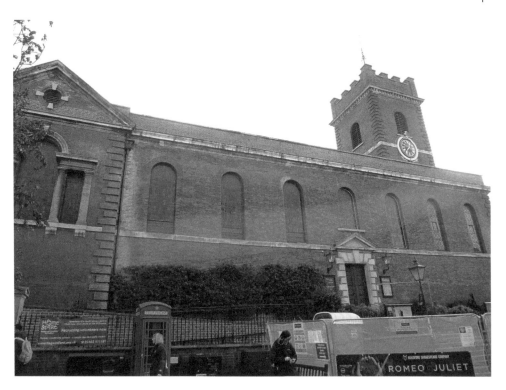

Holy Trinity Church.

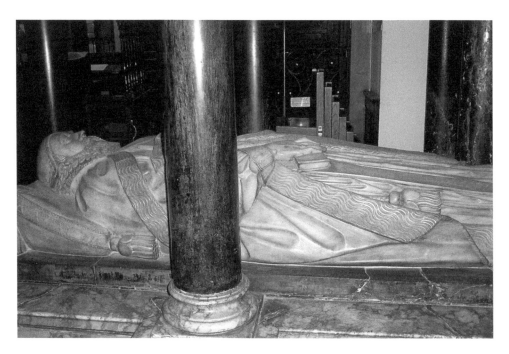

Tomb of George Abbot.

St Nicholas' Church

St Nicholas' Church, situated on the left bank of the River Wey, is a Grade II-listed building. The nearby Friary Bridge leads to the High Street. The architects of the nineteenth-century church, built in the Victorian Gothic style, were Samuel Sanders Teulon and Ewan Christian. It was consecrated in 1876.

Because the church is so near the River Wey, flooding is a constant hazard. The twentieth century started with severe flooding when the River Wey burst its banks, demolishing the nearby medieval Friary Bridge. This was later rebuilt in cast iron and steel. There were more floods in 1928.

Forty years later, in 1968, St Nicolas' Church was badly affected by the floods. On Sunday 15 September there was heavy rain throughout the day. This persistent rain caused the river to burst its banks, flooding into St Nicolas' Church. A dramatic plaque on the north wall shows that the floodwater reached 5 feet on 16 September.

Despite the persistent flooding, the congregation continues to worship regularly on Sundays and activities throughout the week are provided for the congregation and the wider community.

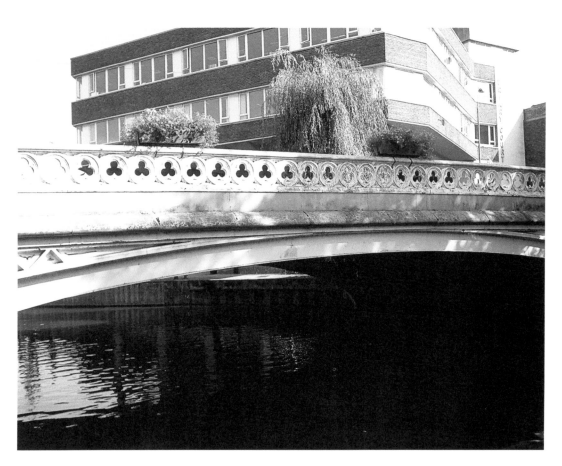

Bridge at the end of the High Street.

6. Guildford Cathedral

For centuries Guildford had been part of the vast Diocese of Winchester. However, as the population grew, it was decided to carve out two new dioceses – Guildford and Portsmouth. In 1927 the Diocese of Guildford was created and its first bishop, the Revd Harold Greig, was installed in Holy Trinity Church in July of that year. He was determined that Guildford should have a cathedral of its own, but the residents of the town were not so enthusiastic. Where was the money to come from? Church attendance was declining and the Depression of the 1920s meant that money was not available for a cathedral that most people did not want.

However, at a conference in May 1928, the diocese decided that a cathedral *would* be built. Their faith was justified when, in November of that year, the 5th Earl of Onslow supported them and donated 6 acres of land on Stag Hill for the purpose. This area had previously been populated only by deer! There were more objections. It was too far outside the town, the land would not be suitable for building and it was an area of natural beauty that should not be spoilt.

In spite of this, the diocese was 'still desirous of building a cathedral' and there was now land on which to do it. In 1930 a competition was announced. Architects were to submit designs for the new cathedral. There were 183 entries and, by the following year, there were five finalists who each received a retainer fee of 500 guineas. The winner, Edward Maufe, was announced in July 1932.

There was still no money. A Cathedral Appeal Committee under the leadership of Lord Middleton was set up. The Mayor of Guildford, William Harvey, was very influential in the town, so Lord Middleton contacted him to ask for his support. He gave it and an appeal was launched in December 1933 with the aim of raising £50,000. When this amount of money had been found, work on the cathedral would start. Meanwhile, a huge teak cross, made of timbers from the nineteenth century battleship HMS *Ganges*, was erected on the summit of Stag Hill. This was unveiled by Bishop Greig the following spring.

By 1936 only £36,000 had been raised and, although this was short of the target, it was decided that building should commence. The bishop suggested that the new cathedral should be dedicated to the Holy Spirit. In spite of various objections, this was agreed and Edward Maufe felt that it was an 'inspiring dedication'. On 22 July 1936 a large crowd gathered to watch the Archbishop of Canterbury, Cosmo Gordon Langley, lay the foundation stone of the Cathedral of the Holy Spirit.

Work now started and 778 piles were driven 50 feet into the hillside on the west side of the teak cross. Maufe had decided that the new cathedral should be made of brick not stone. He had been influenced by a cathedral he had seen in Provence in France and had even brought back to England a brick from that area. He used this as a model for the bricks that were made from the clay taken to make room for the piles. So the bricks were made from the very hill on which the cathedral was to stand.

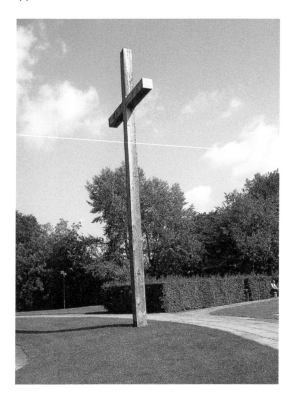

Teak cross.

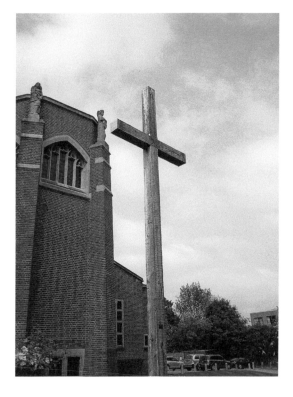

Teak cross in front of the cathedral.

PRAISE GOD for the vision, faith and hard work of ELEANORA IREDALE O.B.E. Secretary of the Cathedral Council through the great building period 1952-1962

Eileen Iredale window.

The building would be of a simple Gothic design but should incorporate both the English spirit and the symbols of the Christian faith. On 25 May 1938 Harold Gamma, the Mayor of Guildford, laid the first brick. The trowel he used was engraved with the arms of the cathedral. By 1939 the choir was complete but lacking a roof. Unfortunately the Second World War held up more building work. However, the crypt was finished and consecrated so that regular services could be held in the crypt chapel until the rest of the cathedral was completed.

It was not until the 1950s that building could be started again, but more money was needed as costs had risen dramatically over the war years. In 1951 Eleanor Iredale, the Secretary to the Council, was appointed as the fundraiser for the cathedral. The salary for her new role was paid by the Maufes. Eleanor thought of an interesting idea to raise money. The cathedral needed bricks, so she suggested that members of the public should be invited to 'buy a brick' for half a crown (two shillings and sixpence). The 'buyers' would have their names recorded in a book.

This was highly successful and both residents and others from farther afield bought a 'piece of clay' to contribute to the building of the first cathedral in the south of England since the Reformation. Until the cathedral was completed, Holy Trinity Church had cathedral status. The east end of the cathedral was almost completed by 1954 and Walton Boulton, the new provost and vicar of Holy Trinity Church, conducted a service in front of the unfinished building. A congregation of 15,000 attended. In 1955 the same number of people joined a diocesan pilgrimage to the new cathedral. An open-air service attended by Princess Margaret was held; a stone in the nave commemorates her visit.

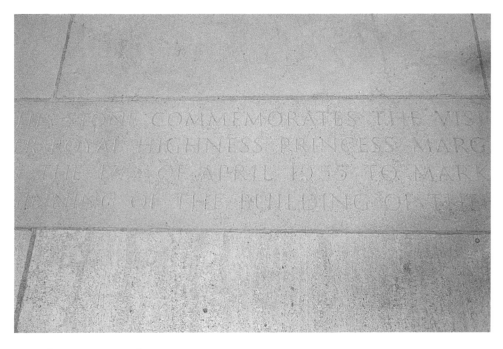

Stone showing progress of nave.

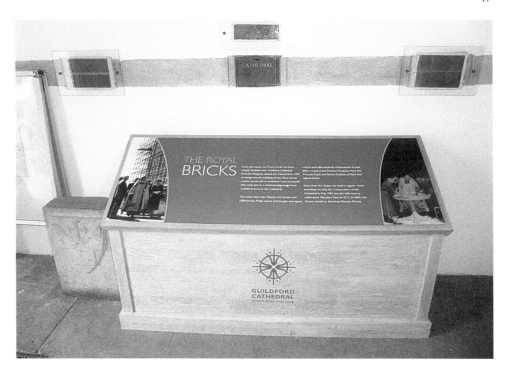

'Royal Bricks'.

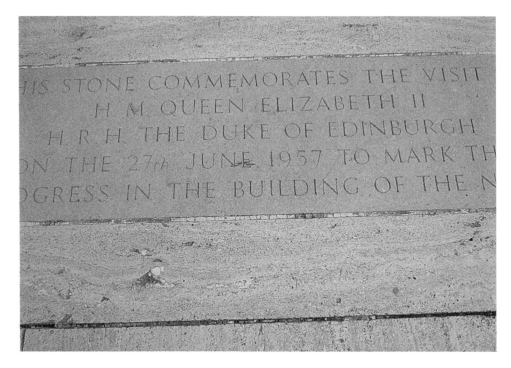

Stone showing nave nearly completed.

The year 1957 was the 700th anniversary of the first charter granted to Guildford. In June the Elizabeth II and the Duke of Edinburgh visited the town and went to the cathedral, where they 'bought a brick', which they signed. These, along with those bought by three other members of the royal family, were not used in the building but can still be seen in St Ursula's Porch on the south side of the cathedral. The other signatures were Princess Margaret, Princess Marina and Princess Mary. By 1957 the nave was almost complete and there is another stone commemorating the Queen's visit. The building work continued but more money was still needed. By 1961 it was still not finished, but as it was suitable for use, it was decided that the consecration service should be held in May of that year.

Sadly, Ivor Watkins, the Bishop of Guildford, had died in 1960, so a new bishop, George Reindorp, was hurriedly appointed. On 12 April 1961, Holy Trinity held its last service as a cathedral when he was enthroned by Vicar Walton Boulton in that church. As the provost of the cathedral, Boulton had expected to be installed as the dean of the new cathedral. However, to his disappointment, he was passed over in favour of George William Clarkson. This caused ill feeling among the congregation as many had wanted Boulton as dean.

Sir Edward Maufe commissioned metalwork designer William Pickford to design a golden angel for the top of the building. Maufe insisted that while the face should be 'sexless', the fingernails and toenails should be 'carefully detailed'. In all his work Maufe paid a great attention to detail. The angel was in memory of a soldier who had died in the Second World War. The consecration of the Cathedral of the Holy Spirit took place on 17 May 1961 on a grey, overcast day. George Reindorp, the 5th Bishop of Guildford, led the service in the presence of Her Majesty the Queen.

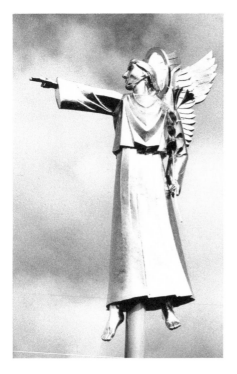

Golden Angel.

It was another forty years before the building was finally completed. The carpet, designed by Sir Edward Maufe, which led to the High Altar was the last handmade carpet to be made by the famous Wilton factory. The arms of the Diocese of Guildford are supported by two angels and below them is a stag, a reminder of Stag Hill where the Norman kings hunted stags. An engraving of a stag in the centre of the nave marks the summit of Stage Hill and the centre of the cathedral. The stag motive is also present in the 1,460 kneelers embroidered by members of the congregation under the leadership of Lady Maufe.

Sir Edward's complete design had included statues to fill the eight niches around the three front doors. It was not until 1999 that a competition was held to find a sculptor to create the statues. This was won by Charles Gurney from York. He sculpted two women and six men whose lives had reflected the Holy Spirit to whom the cathedral is dedicated. He completed the work in April 2004.

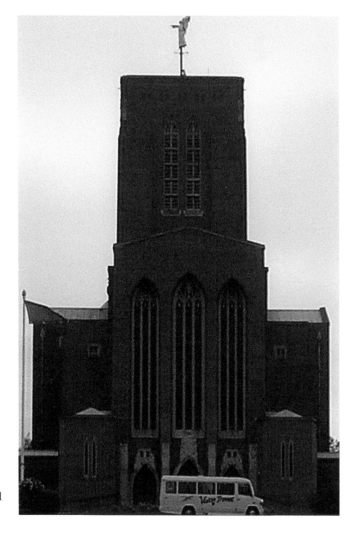

Cathedral with Golden Angel on top.

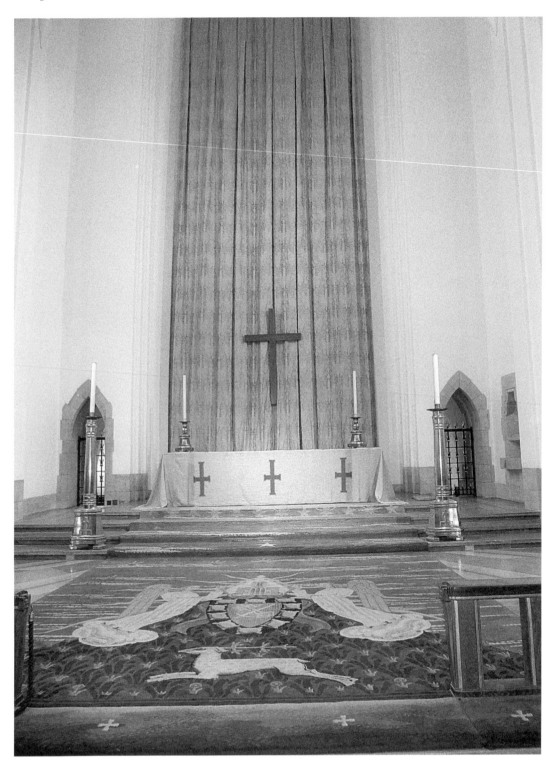

Carpet in front of altar.

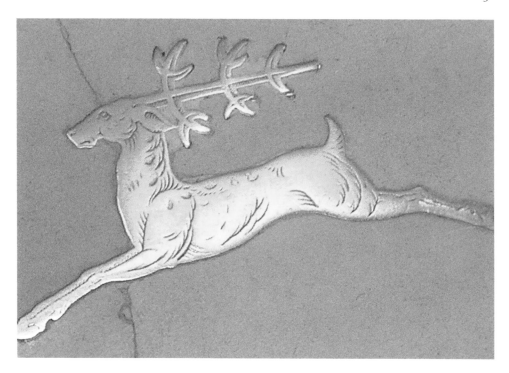

Stag in centre of cathedral.

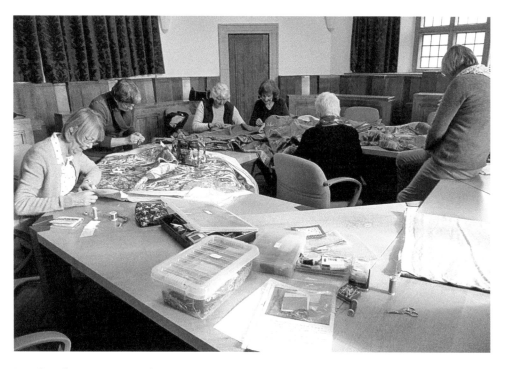

Mending the vestments in Chapter House.

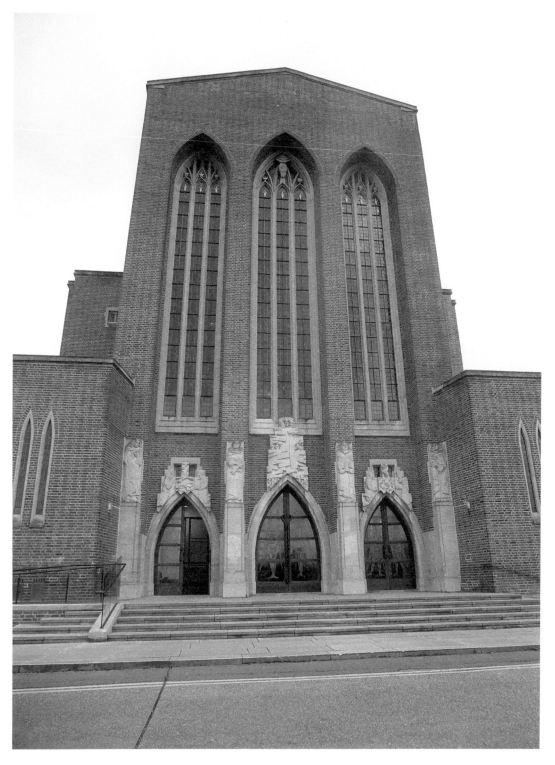

Front of cathedral.

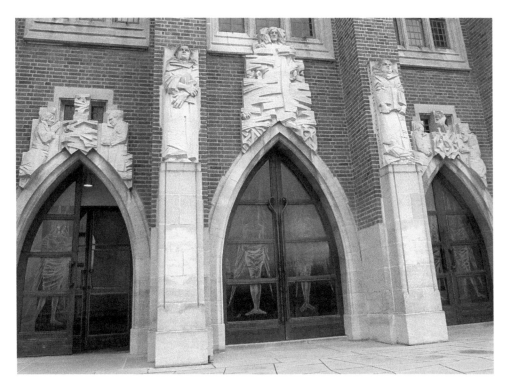

Front of cathedral.

On the north side of the cathedral a small room houses the Cathedral Treasury. This was officially opened on 17 May 1995 by Ian Pickford, an expert on English silver. Some of the objects on show belong to the cathedral but other artefacts have been donated by other churches within the diocese. There are items representing 800 years of church history from the twelfth to the twenty-first century. Two of the most interesting items are a twelfth-century bronze censer cover and a sixteenth-century 'Breeches Bible'.

Also on view is some 'Maundy money'. On 3 April 2006 the Queen attended Guildford Cathedral for the annual 'Maundy Thursday' service at which she traditionally distributed the Maundy money to a group of Guildford pensioners.

Displayed outside the treasury is a fascinating map of the diocese created in 1954 by seventeen-year-old John Clark. Photographs of each church appear in the appropriate place. Much later, after he retired, Mr Clark produced a larger map with photographs of the churches bordering it. On Mothering Sunday in 2000 it was dedicated and now hangs on a wall in the Cathedral Treasury.

Opposite the teak cross at the end of the cathedral are two gardens. One is a Garden of Remembrance dedicated in 1997 and the other a 'Seeds of Hope' garden. On 1 May 2008 this was opened by Dame Jacqueline Wilson, the famous children's author. In the centre are two beautiful statues. A girl blows dandelion seeds that the small boy tries to catch. Around the central area are gardens for each of the four seasons and the Winter Garden includes a small labyrinth marked out on the ground.

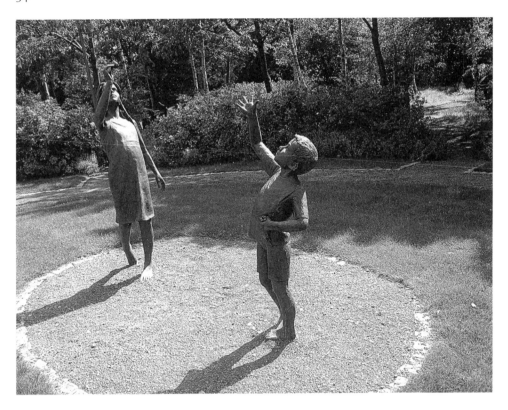

Seeds of Hope Garden.

Since its consecration, the cathedral has been a hive of activity with regular services, exhibitions, concerts and other activities being held inside.

On the southern side another building houses an education centre, a refectory and a gift shop. The latter was opened by the dean, the Very Revd Victor Stock, on 10 January 2011. This was the fiftieth anniversary of the consecration and events to celebrate the Golden Jubilee were held throughout the year. The sculptor, Charles Gurney, created a portable altar and a new font. A concert conducted by the composer John Rutter ended the year of celebration.

During the last few years the cathedral has undergone a major refurbishment for which a great deal of money was needed. The Heritage Lottery Fund provided a major grant and people from all over the diocese contributed generously to repair 'The People's Cathedral'. During the repairs, the cathedral was shrouded in scaffolding but it continued to hold regular services and a huge marquee was erected in front of it. Here, talks, concerts and other events were held.

On Sunday 4 June 2017 the cathedral hosted a huge Beacon event. Worshippers from across the diocese and from different Christian traditions made a pilgrimage to Stag Hill for the Prayer and Food Festival, held in the grounds surrounding the cathedral. The Archbishop of Canterbury, Justin Welby, the Bishop of Guildford, Andrew Watson, and the Bishop of Dorking, Jo Wells, opened the proceedings. Then visitors could visit

The original font.

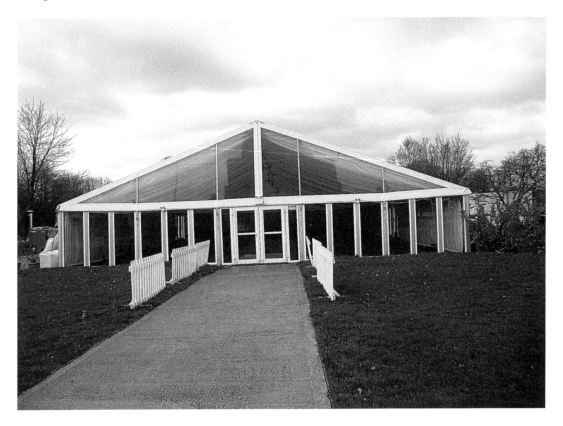

Marquee in front of cathedral.

a variety of prayer stations, which included music, dance, art, meditation and healing. There was also opportunity for family fun with plenty of activities for children, and tempting food could be sampled.

In the evening there was a special Pentecost service held in the cathedral where the scaffolding had been removed. Only 500 people were able to enter the building because of the refurbishment, but hundreds more stood or sat outside in the sunshine listening as the service was relayed to them. The two local bishops, Pete Grieg, a local pastor, and David Welch, the Diocesan Youth Adviser, hosted the mini festival, while the singing was led by the Boiler Room Ignite Band. The preacher was Sarah Rowden, a youth worker.

By the time this book is published, the 'People's Cathedral' will have been restored beyond its former glory – it has been enhanced with the addition of a new lighting and sound system and improved visitor access including a lift. New leaflets, giving details about the cathedral, have been written and volunteer guides are available to take visitors on weekly scheduled tours.

7. Iconic Buildings

The Mill Theatre

In 1251 Henry III set up a fulling mill on the banks of the River Wey in Guildford. Its waterwheels powered wooden mallets that cleaned the wool. The wool trade was an important factor in the development of Guildford. New timber mill buildings were built in 1648. Then, at the beginning of the eighteenth century, a water company was set up and pumps were installed to supply the town with fresh water. The wool trade gradually declined and the fulling mills were converted to grind wheat. This trade thrived and in 1768 brick was used to replace part of the old wooden mills. In 1896 new pumps were installed, the old pump station was demolished and a new brick Toll House was built. This is now a Grade II-listed building.

During the latter part of the nineteenth century the wheat trade declined and in 1894 the milling machines were removed. Turbines were installed and, by the end of the twentieth century, Guildford was ablaze with electricity.

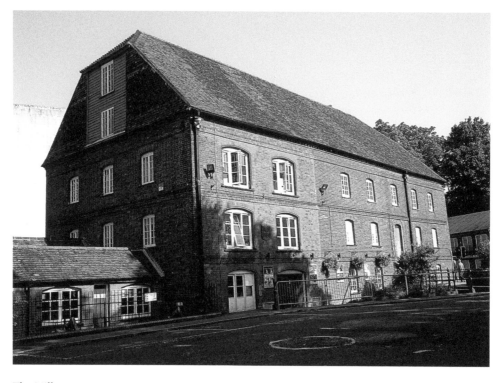

The Mill.

New font in the nave.

In 1966 the Toll House was leased to the newly established Yvonne Arnaud Theatre, which stood next door. At first the building was used for workshops but later it was reorganised. A small intimate theatre, the Mill Theatre, was created. This is ideal for shows using only one or two actors. Props and furniture are kept to a minimum and, today, this small theatre is in constant use and is a popular venue for a night out.

The Guildhall

The guilds were powerful in Guildford in the Middle Ages The head of the Merchant Guild was known as the seneschal. He was always a member of the king's household, so was answerable to the sovereign as well as to the town. Originally the Merchant Guild consisted of all those who had the freedom to trade in Guildford. In 1488 Henry VII granted Guildford a Charter of Incorporation in which he entrusted the administration of the town to the mayor and approved men. In future the mayor was to be elected by the Guild Merchants and was no longer the 'King's Man'. Only members of the approved men could not be members of the Merchant Guild, which met once a year to appoint new officials.

Although there are no detailed records, it is likely that there had been a hall on the site of the present Guildhall since the fourteenth century. During the reign of Edward III there were repairs to 'Gildeford Gild Hall'. The 'Guild' gave its name to the building which became the hub of legal and commercial dealings.

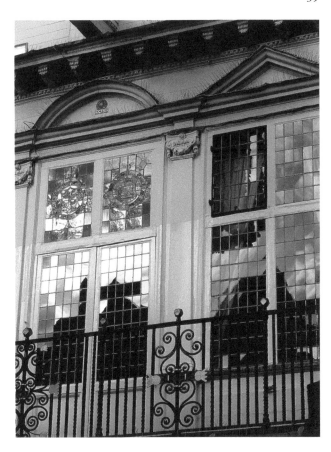

Guildhall.

The current hall, panelled in pine, has no ceiling and the timbers can be seen above. In 1589 the court book notes that 'This year the Guildhall was enlarged and made longer at the north end.' The hall was used mainly as a courtroom but other meetings were sometimes held there.

In 1683 there was a major redevelopment. Over £200 was donated by the citizens of Guildford to extend the upper floor to form a panelled council chamber. At the northern end was a dais on which was the judges' bench. Above this hung a sixteenth-century German sword. Other extensions were added in 1893 and 1934.

Today a long table stands in the centre of the room and, among the portraits on the wall, is one of Elizabeth II commissioned to commemorate her visit to the borough in 1957. This was the year that Guildford celebrated the 700th anniversary of the granting of its first charter. On the south side a narrow balcony looks down on to the High Street; this is still occasionally used on ceremonial occasions.

Hanging outside the Guildhall is the famous seventeenth-century clock for which Guildford is known. Tradition says that this was built by John Alward, a London clockmaker. He presented it to the town in return for permission to set up his clockmaking business in the area. He was responsible for its repairs and in 1684 he was made a Freeman of the Borough of Guildford. Today the clock has to be wound by hand three times a week.

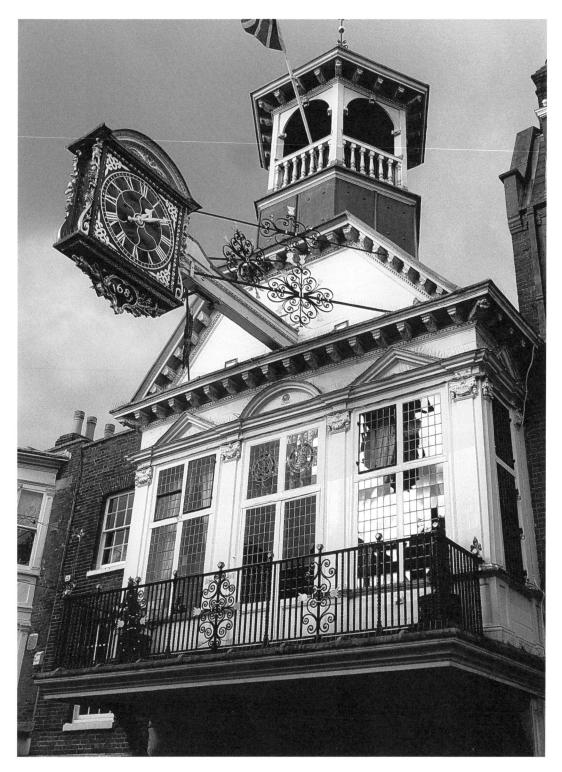

Guildhall with clock.

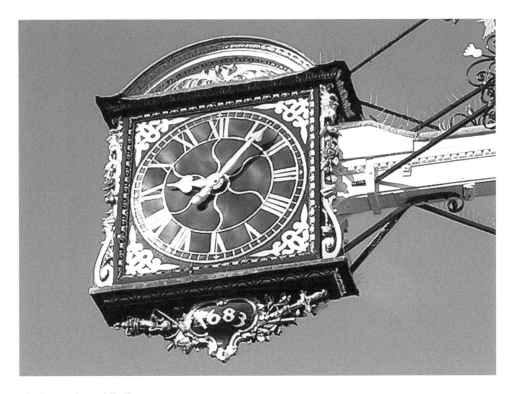

Clock outside Guildhall.

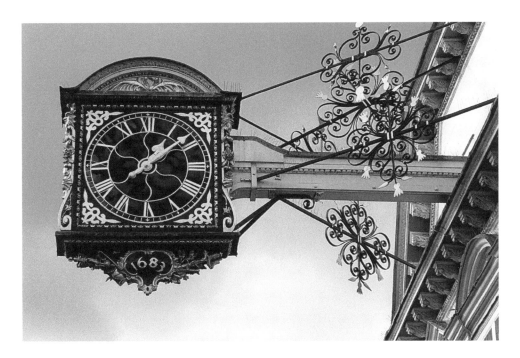

High Street clock.

The Guildhall, the official residence of the mayor, is also responsible for storing and maintaining the town's collection of municipal silver, the borough seals and the maces carried in front of the mayor on ceremonial occasions. The glass cabinet also contains the traditional weights and measures; in the past the mayor and approved men were responsible for ensuring that measurements were always correctly used and recorded.

Today the Guildhall is a Grade I-listed building and the mayor and the council continue to use it.

Abbot's Hospital

Although his clerical duties meant that he did not spend a great deal of time in Guildford, George Abbot remained very attached to his native town. In 1618 he started to plan for a 'hospital' that would cater for unemployed men and women of good character and health who were over sixty years of age. They had to be born in Guildford or have lived in the town for twenty years.

A site was purchased at the top of the High Street and in April 1619 the archbishop laid the foundation stone for what became known as Abbot's Hospital. The building was built from local bricks, and oak from Cranleigh, and Chiddingfold was used for the intricately carved wooden entrance doors on which were engraved Abbot's initials and his coat of arms.

Arms over door of Abbot's Hospital.

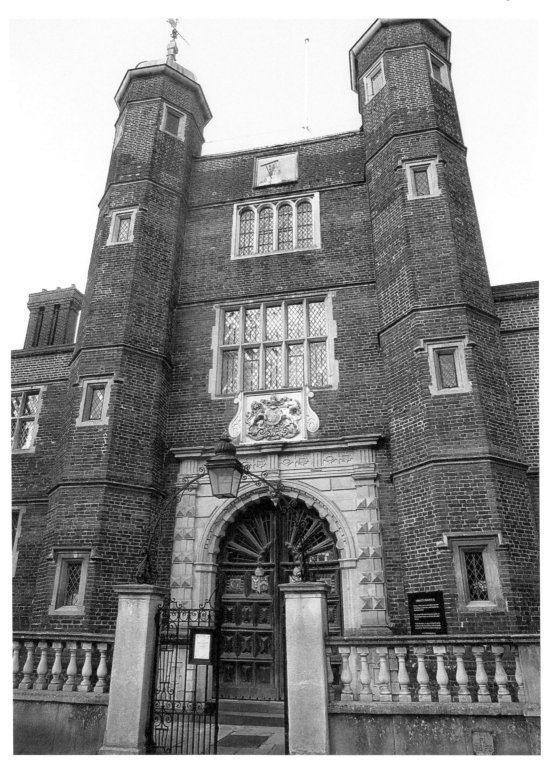

Abbot's Hospital.

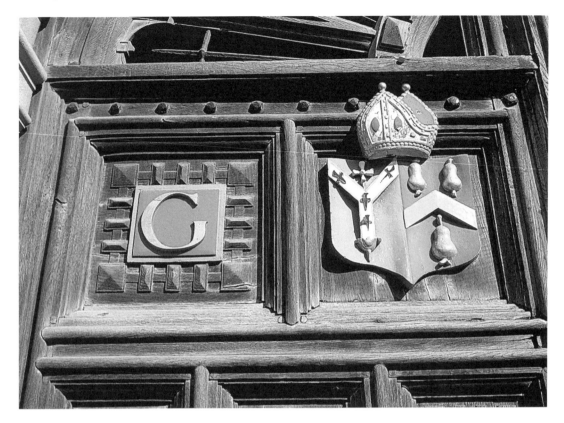

George Abbot's coat of arms.

Above the archway was written '*Deus nobis haec otia fecit*' (God made this for our rest). Through the archway was a quadrangle with rooms on either side. The Master's Lodge was on the corner and the chapel was on the right of the central path. At the end of the quadrangle was the refectory. Meals were cooked in the basement kitchen and vegetables grown in the garden were used.

At one end of the quadrangle a spiral staircase led to Abbot's strongroom where important documents and his valuables were stored in huge wooden chests with robust locks. It was here that on the night of 12 July 1685 the Duke of Monmouth, the illegitimate son of Charles II, was incarcerated on his way to execution in London. A Protestant, he had led an unsuccessful rebellion against the Catholic King James II. The room in which he was held later became known as the Monmouth Room.

By 1622 the new 'hospital' was complete and James I granted it a Royal Charter and the first 'brothers' moved in. Abbot had chosen them himself, giving preference to any who had held office in the town or who had served in the armed forces. Any member of his own family was eligible and his brother, Richard, seventy-three and a widower for twelve years, was installed as the first master. All the residents wore blue gowns with a silver archbishop's mitre embroidered on the left sleeve. Every two years they were issued with a new gown.

29 October 1622 was Abbot's sixtieth birthday and a service was held in the chapel to celebrate the opening of the Hospital of the Blessed Trinity. The first 'sisters' were not admitted until the following year, on 14 March 1623.

To ensure that the hospital was run the way he wished, Abbot issued a set of rules. There was to be no alcohol, no dog was permitted in the building and the garden was to be kept free of 'swine or other noisome beast'. Residents were expected to attend divine service twice a day on pain of fines or even expulsion. The archbishop also declared himself a 'visitor' and regularly visited to check that all was well. Future archbishops retained the title and also visited.

Abbot's Hospital, now a Grade I-listed building, continues to thrive and to serve the older residents of Guildford. It is probably the oldest example of 'sheltered housing' and guided tours of the building are available.

Guildford House

John Child, a wealthy attorney, became Mayor of Guildford three times. Between 1660 and 1680 he built an impressive town house in the traditional 'Artisan Mannerist' style with its classical Doric pilasters. Built mainly of wood, the house retained the original timber frame from a previous building.

The staircase, with its richly carved balustrade in the popular 'Acanthus' style, led to the dining room where two beautiful oriel windows looked out on to the garden and courtyard. In the eighteenth century this room became known as the Sheriff's Parlour. At this time the Assize Courts were held in Guildford and, after hearing the cases, the sheriff and his officials would withdraw to this room to relax. When it was first built, the staircase led to the kitchen below. However, the entrance was later replaced by a cupboard and the kitchen fireplace became a storage cupboard. Today the 'kitchen' is the Gallery Café, which serves a variety of refreshments.

The other room on this floor was probably the main bedroom. Lined with 3-foot-wide pine panels, it still retains the original mantelpiece decorated with carved fruits and flowers. Rooms on the floor above served for the children and personal servants. John Child built the house to show off his wealth and there were a number of storerooms under the front of the house as well as some cellars. Behind the house were the stables.

A brewhouse stood in the courtyard. Beer was the staple drink at the time and was safer to drink than the bacteria-infested water; it would have been brewed in the brewhouse for the family's consumption. Today the brewhouse is a Grade II-listed building and no longer brews beer, but it has been put to other uses. It houses a gift shop and a space for exhibitions and meetings.

In 1736 the Martyr family took over the house and lived there until the 1840s. Later it became a shop and then a restaurant. In the twentieth century it was redecorated and then opened as the present Guildford Art Gallery. The Sheriff's Parlour was renamed after Alderman Lawrence Purcell, an art lover, who had been instrumental in the purchase of the building. Today Guildford House is a Grade I-listed building and houses the Tourist Information Centre.

Guildford House.

Brewhouse.

The Yvonne Arnaud Theatre

During the eighteenth century an enterprising citizen, Henry Thornton, decided that it was time that Guildford had a theatre. He found a small red-brick building in a side street which would seat 400 people. He then applied to the council for a licence to perform a play. This was granted and in 1788 his first production was *Plays, Farces and Interludes*. This played to an enthusiastic audience and for the next sixty years Thornton's Theatre provided a variety of entertainment for Guildford residents.

After the Second World War the residents of Guildford, as well as elsewhere in the country, were tired and ready for entertainment uninterrupted by bombs. In 1946 the Guildford Repertory Company was founded. This performed in the Borough Hall in North Street near the site of Thornton's Theatre. It attracted famous actors and actresses to its stage. One of these was the actress Yvonne Arnaud. Towards the end of her life she moved to Guildford and spent her last days there. She was determined that one day the town would have a proper theatre. Sadly, she died in 1958 before she saw the fulfilment of her dream.

However, she was remembered as one of the prime instigators of a new theatre and in 1961 a national appeal for a Guildford Theatre was launched in her name. £200,000 was needed and the Dorchester Hotel in London hosted the launch. This was attended by many famous actors and actresses. The appeal raised a lot of money and in 1963 building started on the site of the old Millmead foundry on the banks of the River Wey.

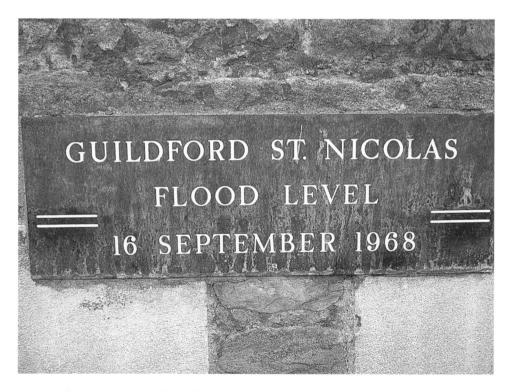

Flood mark outside St Nicolas' Church.

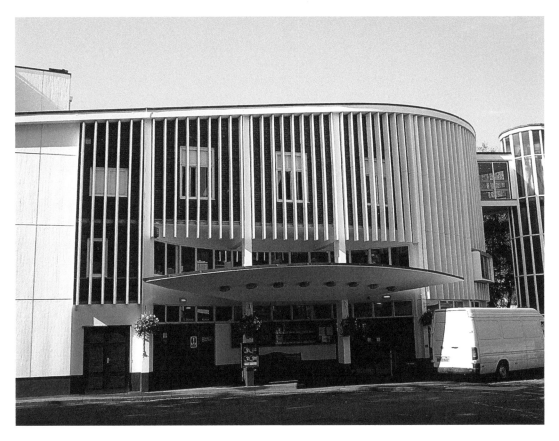

Yvonne Arnaud Theatre.

The actress Vanessa Redgrave was asked to 'make her mark' on the foundations and a plaque on the floor identifies the date on which she did this. The new theatre was completed two years later in 1965. It seated 568 and was named The Yvonne Arnaud Theatre after the actress who had so wanted to see a theatre in Guildford. In June 1965 the theatre opened with a performance of *A Month in the Country* starring Ingrid Bergman. Since that time many famous actors and actresses have graced its stage, often performing in plays that had had their debut in the West End in London.

As well as the café, there is a restaurant serving more substantial meals so theatregoers can enjoy a meal before attending a performance.

Guildford Museum

In 1907 the Surrey Archaeological Society felt that a museum was needed to house the vast collection of artefacts and documents it had acquired. The borough council agreed and Guildford Museum was opened in Quarry Street. It was run by the Surrey Archaeological Society and the council guaranteed it a yearly income, which started at forty pounds and was gradually increased to one hundred. Documents and artefacts bombarded the new museum and in 1933 the council took over the responsibility of running it. Material

belonging to the archaeological society can still be found on the upper floor and the museum still works closely with the society.

In 1947 a professional curator-archivist was appointed. Material from elsewhere in the county had been offered to the museum but the curator decided that as a 'local museum', it should only contain material that illustrated the town of Guildford and its people.

In the twenty-first century one of the rooms in the museum became a 'Victorian schoolroom'. This was created to simulate 'a small village school near Guildford'. Pupils from local schools visited and sat at wooden desks writing on slates while being taught by a Victorian schoolmistress.

The museum continues to collect material from local residents and is used by both researchers and visitors.

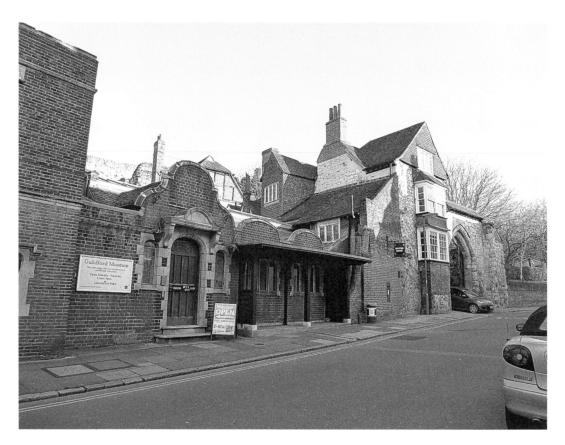

Museum.

8. Eating and Drinking in Guildford

The Angel

It was during the Middle Ages that the impressive Angel Posting House and Livery Stables was built. It is likely that the site had originally contained wooden Saxon dwelling places. The stone-vaulted undercroft with its spiral staircase dates from 1300. The Angel was at first a private house but the first recorded owner in the early seventeenth century was Pancras Chamberlyn. In 1527 he sold it to Sir Christopher More, who passed it on to his son, William.

It had other owners and in 1606 Thomas Hole, a shoemaker's son, inherited it. He rebuilt part of it, introducing distinctive Jacobean woodwork and panelling. During this time it became known as an inn for the first time. A brick fireplace and a minstrel gallery were added in 1685 and a large octagonal 'Parliament clock' was presented to the Angel Inn by the government in 1688. This now hangs beside the main staircase.

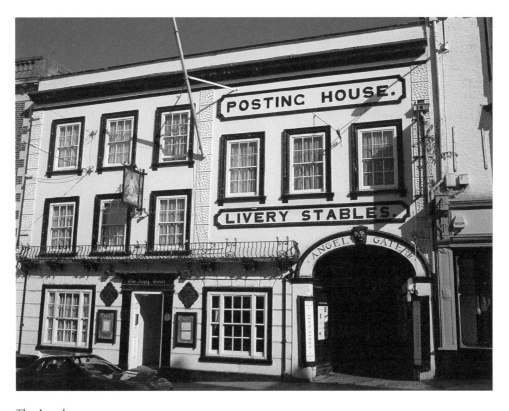

The Angel.

During the seventeenth and eighteenth centuries the Angel became a popular staging post for those travelling between London and the coast. Their horses were stabled in the undercroft.

One seventeenth-century visitor who made use of the Angel was Oliver Cromwell, who billeted his soldiers there and transformed the undercroft into a hospital. Unfortunately, the Angel very soon became bankrupt as Cromwell gave little towards it upkeep and his soldiers had large appetites! Fortunately, when Charles II was restored to the throne money came from the many wealthy travellers who used the popular Angel.

The inn has played host to a number of famous people including Sir Francis Drake, Dr Johnson, Lord Nelson, Jane Austen and Charles Dickens. In the twenty-first century the Angel continues to offer excellent facilities to its guests. The Crypt Bar in the undercroft is a popular venue for special occasions and the restaurant, which serves a variety of meals including cream teas, is situated in the ballroom of the original house. Four of the twenty-one rooms boast four-poster beds and tradition says that seventeenth-century soldiers haunt the building!

Olivio's Restaurant

Olivio's restaurant in Quarry Street dates back to Elizabethan times. It still retains some of its original features with timber beams, delicate woodwork and an impressive fireplace hiding behind the bar. The earliest written record of the building in 1745 notes it as The Kitts, a public house. Retaining its function, it changed its name several times over the next few years; it became The Sheep Shearers, The King's Head and The Sun. Then in the eighteenth century it became a butcher's shop.

In the nineteenth century it again changed its function. The population of Guildford had grown rapidly and a hospital was needed. Before one could be built, the butcher's shop became the Guildford Dispensary, which opened to provide care for the sick. It was funded only by voluntary contributions and patients who were treated, contributed whatever they could afford. Doctors were also available to visit 'those who lived within two miles of Guildford'.

More than 1,000 patients were treated during the first year. Eventually, in 1862, plans for a new hospital were drawn up with the help of the famous nurse Florence Nightingale. In July 1863 the foundation stone was laid and building commenced. The Royal Surrey County Hospital opened on 27 April 1866. There were two wards each containing sixty beds. It was funded by voluntary contributions, but fortunately the citizens of Guildford proved generous. Fundraising events were also held.

When the hospital opened, the Guildford Dispensary was no longer needed and returned to its original function as a public house. However, later it became an antiques shop. Then in 1997 it changed once more and opened as Olivio's restaurant. Today it is a Grade I-listed building. A plaque on the wall outside it tells visitors its history: 'From 1859 to 1866 this building housed the Guildford Dispensary providing the medical care for the poor of the town and was the immediate forerunner of the Royal Surrey County Hospital.'

Olivio's restaurant.

The Star Inn

The Star Inn in Quarry Street was built around 1600. A timber-framed building, it has three levels and a projecting upper floor or jetty. It has recently been renovated but has retained its historic features. On one of the timber beams three crosses are marked. Their origin is obscure but there are three possibilities for their symbolism – the Trinity, the Three Ages of Man or the Past, Present and Future. The crosses are said to bring good luck to all who pass beneath them.

The Star Inn has been providing refreshment and entertainment for Guildford residents for over 400 years. In the past, Twelfth Night (6 January) was traditionally a time for celebration and jollity. In Guildford a group of Morris men and mummers processed up the High Street. The celebrations started at The Star Inn. A wassail bowl filled with 'seasonally spiced liquor' was provided for the entertainers and a large fruit cake was shared. One slice contained a bean. The recipient of this bean became the King of Misrule. He ordered the mummers to perform their play beneath the timber crosses.

Following this, the mummers and Morris men processed up the High Street, stopping at each pub to enjoy more refreshment and ritually chalk a cross on one of the beams. Known as an apotropaic mark, this was thought to bring good luck and prevented the entrance of evil spirits. By the time the procession reached The Royal Oak, the men must have been very drunk!

Crosses in The Star Inn.

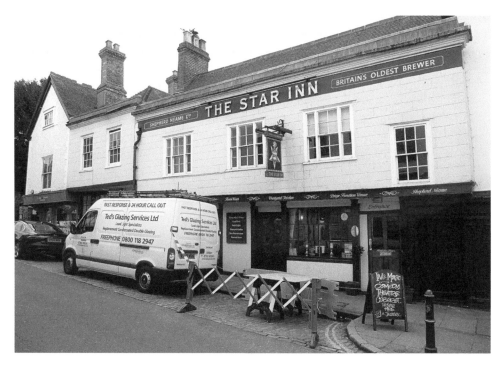

Star Inn.

Since 1972 this tradition has been revived by the Pilgrim Morris Men. Like their predecessors, they tour Guildford's pubs and perform the *Guildford Mummers' Play*. They also sing traditional carols and the time is greatly enjoyed by both performers and audience.

The Star Inn also provides music for its customers throughout the year. It has been described as the 'longest-running live music venue' and is said to provide 'beautiful beer' and a 'brilliant band'.

The Three Pigeons

The Three Pigeons, a traditional English pub, is situated at the top of the High Street. It was probably built in the middle of the eighteenth century with dark wooden floors and a spiral staircase. Sadly, much of it was destroyed by fire in 1916. When it was rebuilt in 1918, its design was influenced by a seventeenth-century house in the High Street in Oxford.

Reputed to be haunted, it still serves its many customers beer, spirits and wine as well as traditional British meals. The Morris men take advantage of its hospitality when they process up the High Street on Twelfth Night before ending their evening at The Royal Oak, which stands behind Holy Trinity Church.

The Three Pigeons remained standing when the building next to it was demolished in 1913. This was Gates Grocery. The owners supported the temperance movement and they were so against the consumption of alcohol that tradition says they poured wine and spirits down the drains! Eventually they concentrated on selling only dairy products and became the well-known local firm of Cow & Gate.

Plaque outside The Three Pigeons.

Today, The Three Pigeons continues to provide traditional British food including a variety of pies and a good selection of wine and beer. On Sundays it stays open until five o'clock and serves a traditional British roast of beef or lamb. However, it also serves a tapas selection and pasta. As well as a gluten-free menu, there is a brunch menu. Groups of seven or more celebrating special occasions can also be catered for.

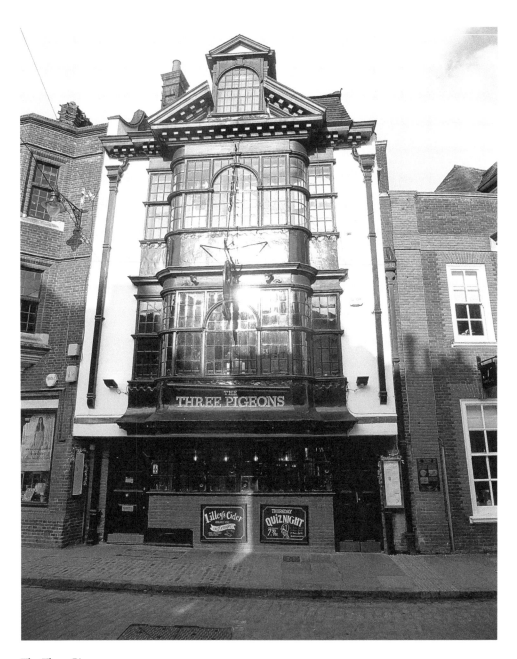

The Three Pigeons.

The Royal Oak

The Royal Oak has been described as a 'hidden gem', although in recent times it has become one of Guildford's busiest pubs. To reach it, the visitor takes the flight of steps to the left of Holy Trinity Church. The path at the top of the steps passes the well-kept graveyard and leads to a row of buildings of 'special interest' including The Royal Oak. Its entrance overlooks the graveyard and, beside the door, tables and chairs await the summer visitor.

Originally built around 1500 as part of the rectory of Holy Trinity Church, it was a medieval timber-framed house; the huge hall on one side had a roof with timber archways but no ceiling. On the left were the living quarters with a bedroom on the first floor. Food was stored and prepared on the ground floor.

During the centuries the vast hall was used for a variety of purposes: visiting dignitaries were entertained, meetings were held and church officials met to ensure the smooth running of the church. In 1699 Holy Trinity Church became a combined parish with St Mary's Church in Quarry Street and one priest was appointed to run both churches. In 1806 the rectory was sold and in 1840 iron railings were erected in front of the graveyard. A narrow path provided access to the buildings.

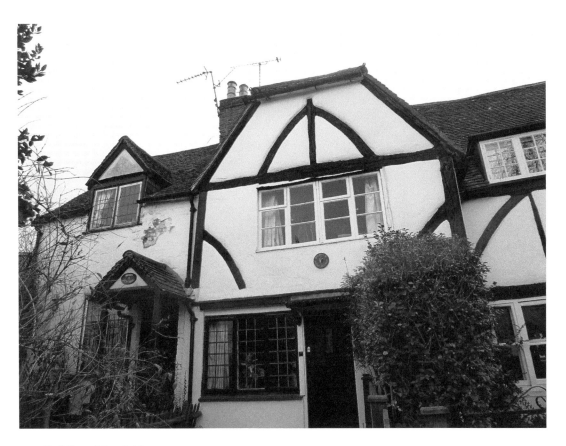

Building of Special Interest.

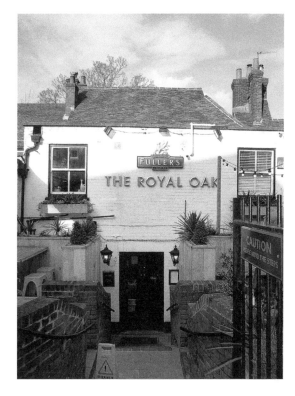

Left: The Royal Oak.

Below: The Royal Oak.

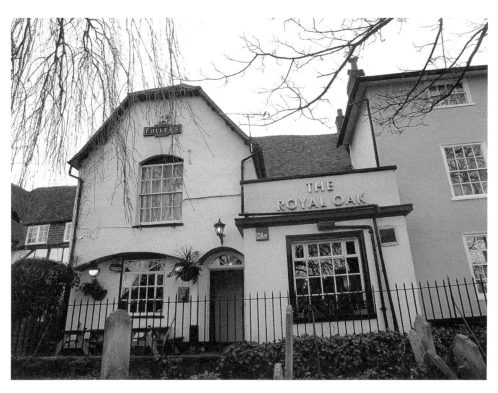

In 1870 it had a change of status when the west wing of the building became a public house. With Guildford's royal connections it became The Royal Oak, although there is no evidence that Charles II ever visited the town. However, one of his illegitimate sons, the Duke of Monmouth, did visit the town but he was imprisoned in Abbot's Hospital. He had rebelled against James II and was on his way to execution. The pub sign, outside the entrance in Sydenham Road, shows the king's head in front of the oak tree in which he had hidden from his enemies.

Once owned by George Trimmer, a brewer from Farnham, the pub was taken over by Courage in 1951. Today it is owned by Fuller's Brewers and Russell Scobbie became the landlord in 2016. He felt that the pub was 'rather tired' so set about renovating it to make it fit the twenty-first century. It is still traditional but has a 'contemporary slant' with a TV screen and a projector screen for large sporting events. It also welcomes bands on a regular basis. The Royal Oak also hosts various events, a popular one of which is the Burn's Night Supper where 'hagis, neeps and tatties' are served with whiskey sauce.

One visitor described The Royal Oak as 'a touch of tranquillity in the centre of a busy town'. It is certainly worth a visit.

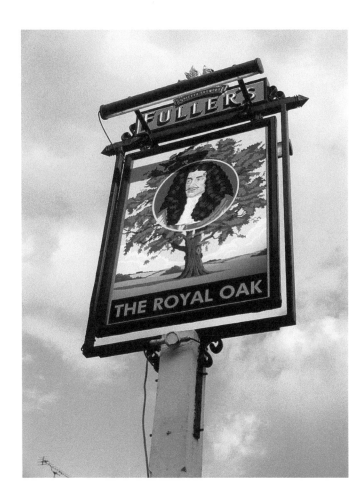

The Royal Oak sign.

Crosses in The Royal Oak.

Fireplace in The Royal Oak.

Russel and Rachel behind the bar in The Royal Oak.

The Jellicoe Roof Garden

From the Jellicoe Roof Garden, with its delightful tea terrace, the visitor can look over the historic town of Guildford. Situated on the top of what was originally Harvey's Department Store, it was created by the famous landscape artist Sir Geoffrey Jellicoe in 1958. He saw it as 'primarily a sky garden' with the water reflecting the changing pattern of the clouds. His idea was to 'unite heaven and earth' so 'the sensation is one of being poised by the two'. The first Sputnik had recently been sent into orbit so his garden would symbolise the vehicle's flight.

When the company House of Fraser took over the building in 2000, the Jellicoe Roof Garden was demolished and then recreated using Jellicoe's original plans. The flower beds were refreshed in 2008 when herbaceous perennials and ornamental grasses were planted. Two years later, in 2010, Jellicoe's Roof Garden was featured in *Gardener's World*.

It is a popular venue at any time of the day and provides a varied menu for lunch, cream teas and delicious cakes. Jellicoe's Roof Garden is a Grade II registered site in the Parks and Gardens Register of English Heritage.

Jellicoe Gardens.

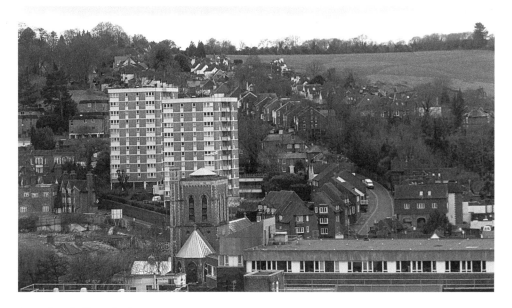

View from Jellicoe Gardens.

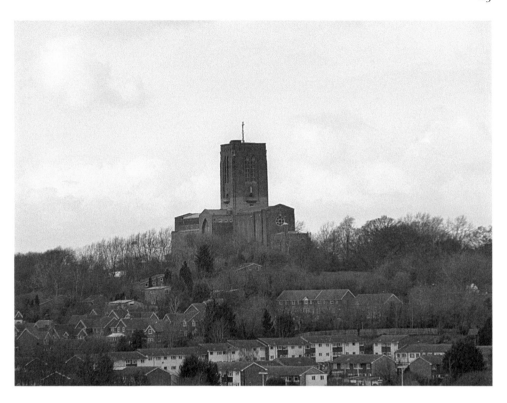

Above: View of cathedral from garden.

Right: Tearoom.

9. A Guildford Miscellany

A Public Execution

On 9 July 1709 Christopher Slaughterford was publicly hanged in Guildford for the murder of his fiancée, Jane Young. He had always strenuously protested his innocence, accusing one of his servants of the crime. At an earlier trial in Kingston, he had already been acquitted but the prosecution had not been satisfied with the verdict.

A second trial was held in Guildford and, on this occasion, Slaughterford was found guilty of Jane's murder and sentenced to death. The prosecution based their case solely on circumstantial evidence. The accused had, in fact, a strong alibi for the time of the murder.

Before he went to the gallows, the condemned man wrote and signed a statement protesting yet again that he was 'wholly innocent' of the crime of which he was accused. He forgave his 'enemies' and prayed 'to God to give them a due sense of their errors' hoping that God would 'in his due time ... bring the truth to light'.

Sadly, this did not happen and Slaughterford went to the gallows in front of a large Guildford crowd for a crime that he probably did not commit.

The Fire Service

In the first half of the nineteenth century Guildford was ill-equipped to deal with fires. Although it possessed two fire engines, they were not stored in the same place. One of them resided in the town hall and the other at Tunsgate. One of these even required the mayor's permission to travel more than 5 miles from the town! The essential buckets and ladders were also stored elsewhere and, in the case of a fire, it took some time to unite the engines with the other essential items.

To quench a fire, water, of course, is essential, but this was not easily available at this time; to prevent leaking pipes from flooding the town, the water mains were turned off at night. In June 1851 one of the shops in the High Street caught fire. The landlord of the George Inn came to the rescue by offering the tank of water stored in the courtyard of the inn.

The town eventually decided that something had to be done. A volunteer fire brigade was formed in 1863; a new horse-drawn fire engine was purchased and a shed was built in North Street to house it.

Then, in 1872, Henry Peak, the county surveyor, was asked to design a new brick fire station to replace the shed. When it was built, a motorised fire engine was bought to replace the horse-drawn one. By the end of the century Guildford had, at last, acquired a more professional fire service.

The Guy Riots

The Victorians loved a party and Guy Fawkes Night on 5 November was the perfect opportunity for one on a grand scale. Between 1820 and 1865 this was celebrated in Guildford every year. A group of men known as the 'Guildford Guys', dressed in a variety of costumes, marched up the High Street carrying firewood and flaming torches.

They deposited the wood at the top of the High Street outside Holy Trinity Church and set fire to it. As the flames leapt up, the men danced around the bonfire and were joined by thousands of Guildford residents. Home-made fireworks were set off and everyone enjoyed a great time.

As the fire started to burn down, there was a scramble to find more wood. Fences were torn down and other wood was salvaged and thrown onto the fire. The partygoers became more boisterous but even the more sober regarded it as 'a bit of fun which happened only one a year'.

However, over the years the revellers became more rowdy and the 'party' became a 'riot'. Guildford was not the only place where rioting took place. The streets of England had become increasingly lawless with bandits waylaying unwary travellers and burglary a common occurrence. In 1715 the government took action and passed a law known as the Riot Act. This was to be read when a group of twelve or more people were causing a disturbance. After it was read, the rioters had to disperse and if they did not do so, they would be arrested.

During the following century Guildford had to make use of this Act on several occasions when the town was celebrating on 5 November. In 1843 two of the ringleaders were taken to court and heavily fined. However, the celebrations continued and every year they became more violent and dangerous, giving rise to the name the Guy Riots.

The rioting reached a climax in 1865 when it continued for two months until Boxing Day and the rioters were out of control. Eventually the military had to be called in to end the bonfire celebrations. The streets of Guildford became lined with army officers. The town finally realised that what had been a great party had developed into a dangerous riot which had to stop.

Today, more carefully organised celebrations have replaced the traditional Bonfire Night. In 2015 Guildford celebrated the final dismantling of the Guy Riots.

Surrey University

The idea of a university in Guildford was first suggested in two speeches to the local rotary club in the 1960s. Members of the club and others were enthusiastic and a committee was formed to discuss the idea in more detail. During this time technology was becoming increasingly important and many felt that a new university with a technological bias would be an excellent addition to the town.

Battersea Technical College had been founded in the nineteenth century as a charitable institution. Its first students were admitted in 1894. It became Battersea College of Advanced Technology in 1957, one of the first colleges to be awarded this title. By this time it had outgrown its original building and needed a new site away from the capital.

The committee in Guildford had decided that Stag Hill next to the cathedral would be an ideal position for the new university. The Church and academia had always worked closely together. In March 1963 the borough council agreed that a university would benefit the town. However, not all residents shared their view. Students at this time had a very bad press because of the student riots both in Europe and in the United Kingdom. It was felt the 'idle unwashed students' had no place in the refined town of Guildford.

The nearby village of Onslow also objected as part of their land had been allocated for the new building. In 1954 the village's application to build houses had been rejected so the villagers were not happy that, in the 1960s, buildings were to be erected there for 'foreigners'. A compromise was eventually reached. It was decided that part of this land should be used only for playing fields and not for buildings.

On 24 October 1963 the government accepted the recommendation of the Robbins Report. One of these gave the status of 'University' to Colleges of Advanced Technology. Battersea College was now a university and looking for a new site. What better place than Guildford? In May 1964 the Secretary of State for Education and Science agreed that the University of Surrey would be established in Guildford 'on a site to be provided from a fund to which both the governing body and the county council will contribute'. Battersea University would relocate to Stag Hill and become the University of Surrey.

Building in the University of Surrey.

Because of the continued protests, it was not until January 1966 that work on the site finally began. On 9 September 1966 the University of Surrey was granted a Royal Charter and in October, its first chancellor, Lord Robens, was installed in the Civic Hall. The vice-chancellor was the erstwhile principal of Battersea University. In June 1967 the first students arrived, negotiating their way over the building site that was the new university. The first graduation ceremony was held in 1970 in the Civic Hall. Today they are held in the cathedral.

Finally completed, the university flourished. In the 1990s it won two awards for achievement. In 2002, to celebrate its thirty-fifth anniversary, the sculptor Allan Sly was commissioned to create the *Surrey Scholar*, which stands at the bottom of the High Street. On 29 May 2002 it was unveiled by the Duke of Kent revealing the words on the plaque, 'This sculpture was presented to the Borough to celebrate Guildford as a place of culture and scholarship by Professor Patrick Dowling, Vice-Chancellor, on behalf of the University of Surrey.'

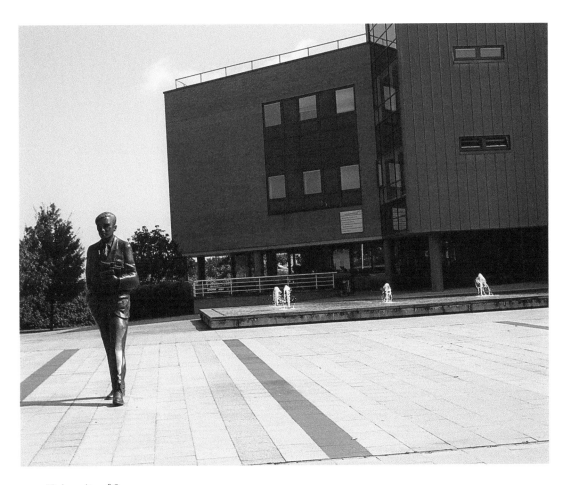

University of Surrey.

University of Surrey.

Surrey scholar.

Floods

As the River Wey runs through Guildford, the town has been flooded on several occasions. The twentieth century started dramatically when, on 15 February 1900, the river burst its banks and water flooded the High Street. Morris's Timber Yard, which was at the bottom of the High Street, was overrun with water and much of its timber was swept downriver. This crashed against the fragile medieval wooden bridge, smashing it to pieces.

The bridge had to be replaced. When the water had receded, the remains of the old wooden bridge were demolished and work started on a more substantial one made of cast iron and steel. This was finally completed in 1902.

Monday 29 May 1967 had scattered showers, although that month had been the wettest May since 1773. On the May Bank Holiday, when the County Show was being held in Stoke Park, disaster struck. Visitors, tempted by the sun, drove to the park. Unfortunately the car park was not tarmac and rain had saturated the earth on which the cars were parked. That day 1,000 of them were held fast by the mud and tractors had to be summoned to haul them out.

The following year Guildford was again flooded. On Sunday 15 September heavy rain fell the whole day and, inevitably, the River Wey burst its banks. Five feet of water seeped into St Nicholas' Church close by the river. Today, a plaque on the west wall outside the church can be seen showing the flood level on 16 September 1968. The nearby Yvonne Arnaud Theatre was also flooded.

Over the years Guildford has become adept at clearing up after a flood and restoring the town to normality.

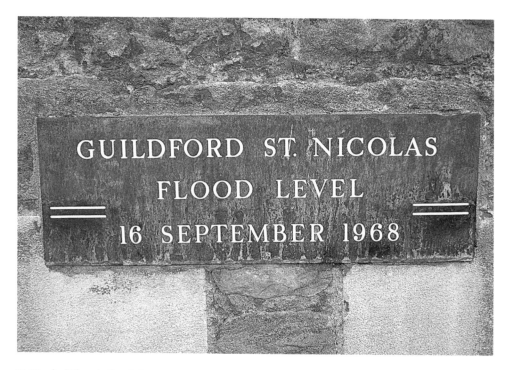

St Nicolas' Church flood sign.

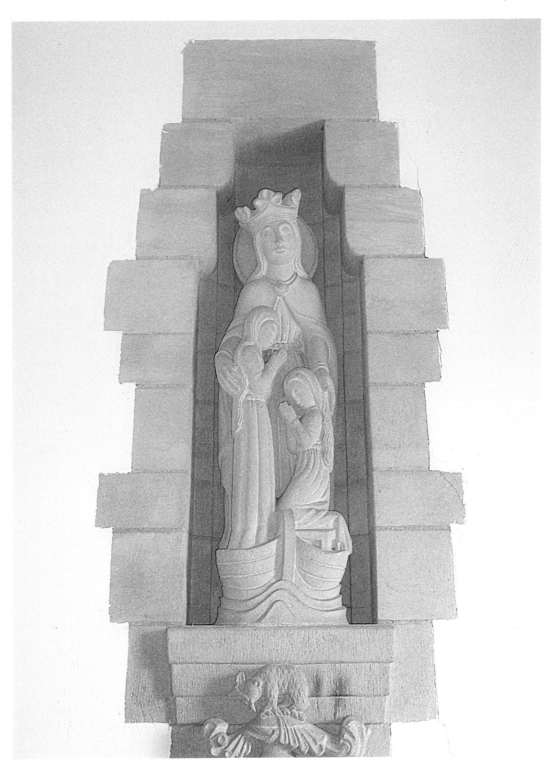

St Ursula.

St Ursula

The porch on the north side of the cathedral which displays the bricks signed by the royal family is called St Ursula's Porch. St Ursula was the patron saint of schoolgirls. In the niche in the east wall of the porch is a statue of her created by the sculptor Vernon Hill. She stands with her arm around a young girl while a small child kneels at her feet. This was donated by a Mr FitzSimon in memory of his wife, Ursula.

Vernon Hill had a workshop in London and this is where he created the statue during the 1940s. When it was completed, he put it in a taxi and drove with it to Guildford. Fortunately it arrived safely but statue and sculptor had a narrow escape. A few days later Vernon Hill's London studio was completely destroyed by one of the many bombs dropped on London at that time.

A Celebrity Wedding

On 19 February 1964 a celebrity wedding took place at Arlington House, the Guildford Register Office in Portsmouth Road. It had been a whirlwind romance of only ten days. Britt Ekland, the twenty-one-year-old Swedish starlet, was staying in the Dorchester Hotel where she was about to start filming her new movie *Guns at Batasi*. Also staying there was the thirty-eight-year-old British actor Peter Sellars. He said later that it was 'love at first sight'. However, when he invited her for a drink, she did not at first realise who he was!

News of the wedding soon leaked out and around 1,000 fans gathered outside the register office to await the arrival of the stars. They were not deterred by the falling snow. Peter Sellars, wearing a midnight-blue suit and taped trousers, arrived in a maroon Lincoln convertible, driven by his chauffeur, Bert Mortimer. His bride, accompanied by her parents, was driven in black Rolls-Royce. Over her Norman Hartnell wedding dress she wore a mink coat, her bridegroom's wedding gift to her. Her long blond hair had been swept up and a white petal hat was perched on top. When they arrived, the couple posed for photographs while the crowd cheered.

During the fifteen-minute service, led by Superintendent Registrar George Catt, the couple exchanged white gold wedding rings. When they left, they had difficulty reaching Sellars' car because of the crowd of well-wishers surrounding them. When they were finally seated in the vehicle, the fans did not disperse, so it took the driver ten minutes to drive the 80 yards to the main road. He then sped off to Brookfields in Cutmill Road, Elstead, where a reception was held for thirty guests. Peter Sellars' enterprising nine-year-old son by his previous marriage sold pieces of wedding cake to the villagers who were crowding round the front gate!

Sadly, the marriage only lasted four years and the couple were divorced in December 1968.

The Guildford Four

Guildford did not escape the Irish Troubles in the 1970s. On Saturday 5 October 1974 at 8.30 p.m. the Provisional Irish Republican Army detonated a 6-pound gelignite bomb at the Horse and Groom in the High Street. They knew that the pub was frequented by members of the British Army. Two men from the Scots Guards, two women of the

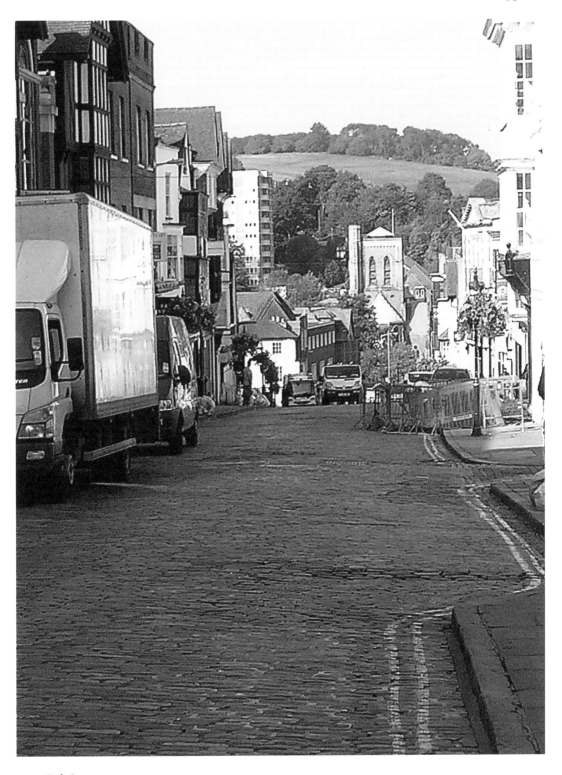

High Street.

Women's Royal Army Corps and a civilian were killed. Sixty-five others were injured. The IRA also targeted the nearby Seven Stars. When the first bomb went off, this was immediately evacuated so there were no serious injuries from the second bomb.

Three months after the incident, Gary Conlon, Paul Hill, Patrick Armstrong and Carole Richardson were arrested for the crime. The trial took place the following year and in October 1975 they were found guilty and imprisoned. Known as the 'Guildford Four', doubts about their convictions soon arose and appeals were launched. However, it was not until they had been in prison for fifteen years that there was a successful appeal. The Judges felt that the four had made confessions under duress and some evidence had been suppressed. The prisoners were eventually released.

No one else has ever been charged with perpetrating the outrage in Guildford in October 1974.

A Shooting at the Cathedral

Usually the grounds of the cathedral are peaceful. If the weather is mild, visitors can enjoy the tranquil atmosphere as they wander around gazing at the impressive structure in front of them. However, on the afternoon of Sunday 30 November 2008, the tranquillity disintegrated when thirty-nine-year-old David Sycamore appeared, waving a gun.

The police were immediately alerted and a number of officers swarmed towards him while a helicopter hovered overhead. The intruder, who had lived in Guildford all his life, was eventually shot dead by a police marksman. It was later discovered that he had suffered from depression and the gun he was holding was a replica. His parents described him as 'a lovely son' but said he had told them that 'he wanted to die in Guildford as he loved it so much'. Sadly, he had his wish on that fateful Sunday.

The dean of the cathedral was not happy with the way the event had been handled. He felt that the cathedral authorities should have been notified earlier. While he understood the pressure faced by the police, he did not think they had given 'enough consideration to the fact that Mr Sycamore was on sacred ground'. Neither was he happy that the police decided to cancel the Advent carol service scheduled for that evening.

Also available from Amberley Publishing

Explore Woking's secret history through a fascinating selection of stories, facts and photographs.
978 1 4456 5144 6
Available to order direct 01453 847 800
www.amberley-books.com